IMAGES
of America

DOWNINGTOWN

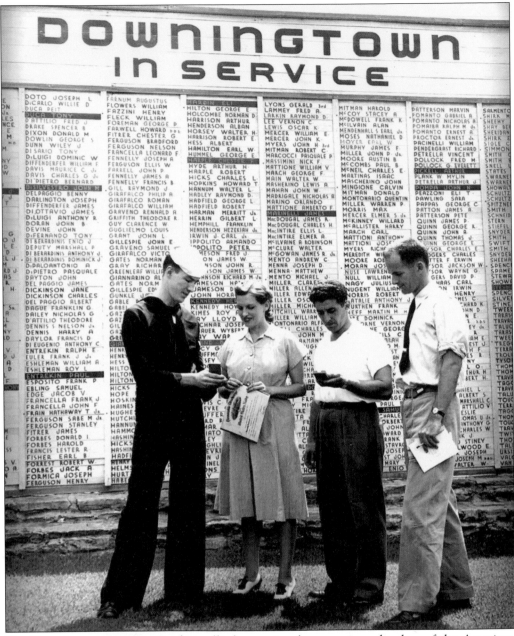

The Downingtown community has rallied to national causes since the days of the American Revolution. The village, then known as Milltown, housed a depot for supplies for Gen. George Washington's army during the Philadelphia campaign in the summer and fall of 1777. In this 1948 photograph by Alfred Giannanino, a member of the U.S. Navy (with a large military service board serving as a background) shows off a medal he has received. The woman next to him is holding a certificate issued by the U.S. Navy. This book has a number of other patriotic photographs, including ones of a Memorial Day parade, residents selling bonds to help support World War I, and patriotic organizations.

IMAGES
of America

DOWNINGTOWN

Bruce Edward Mowday

ARCADIA
PUBLISHING

Copyright © 2004 by Bruce Edward Mowday
ISBN 978-0-7385-3523-4

Published by Arcadia Publishing
Charleston, South Carolina

Printed in the United States of America

Library of Congress Catalog Card Number: 2003116600

For all general information contact Arcadia Publishing at:
Telephone 843-853-2070
Fax 843-853-0044
E-mail sales@arcadiapublishing.com
For customer service and orders:
Toll-Free 1-888-313-2665

Visit us on the Internet at www.arcadiapublishing.com

On the cover: Downingtown High School band members pose in 1930 or 1931.

CONTENTS

ACKNOWLEDGMENTS

The members of the Downingtown Area Historical Society—especially the organization's president, Roger Grigson, and his wife, Carol—made this photographic history of Downingtown possible. Roger Grigson is more than the president of the historical society, as he provides the spirit and the vision for the group.

The Downingtown Area Historical Society has a new home, one of the oldest buildings in the area, the historic Ashbridge House in East Caln Township. The structure was saved because of Roger's foresight and the hard work of his wife and the rest of the members of the historical society. A portion of the proceeds from this book will go to the historical society and will be used in maintaining the Ashbridge House.

When Roger and Carol approached me about coordinating the book project for the historical society, I immediately accepted for several reasons. I have worked with Arcadia Publishing on two previous books, *Along the Brandywine River* and *Coatesville*, and I value the quality products the company produces. The publishing company should be commended for preserving the histories of our communities. As a member of the Downingtown Area Historical Society, I know how valuable this organization is to the Downingtown community, and I would like to contribute to its success.

Also, I lived in the borough of Downingtown for more than a decade. My daughters, Megan and Melissa, spent their youth in Downingtown and received an excellent education in the Downingtown school system. I continue to have a connection to the area, as I live in the coverage area of the historical society.

The creation of a photographic history of any community requires a lot of work to obtain the images and to organize the book. Susannah Brody, a member of the historical society, offered major assistance by being the point person for the initial gathering of the images, keeping a record of those members who offered images to be used in this book and aiding in the verification of information used in the captions. She deserves a lot of credit for this book.

Katherine Harlan, my wife, has aided in the publication of all of my books, including this work on Downingtown. Besides being an excellent copyeditor, she always provides excellent creative and marketing ideas. Gene DiOrio, who worked with me on the Coatesville book for Arcadia, loaned to me his 1909 copy of *The History of Downingtown*, by Charles H. Pennypacker, to help in my research. I also consulted Jane Davidson's *A History of Downingtown*.

Most of the images in this book are the property of the Downingtown Area Historical Society. An important segment of the historical society's material is composed of the Joseph E. Miller collection. A chapter of this book includes many images from the collection.

Individual members of the historical society and the community opened their personal collections to contribute to this book. They all deserve thanks for their generosity. Those members include Dorothea Parker, Ruth Lowe, Doris Keen, Nancy D'Angelo, Doris Yocum, Alfred Giannanino, Mark Mowery, Dorothy Miller Plank, Dorothy A. Plank, William Barrett, Harlan Usher, Louise Corrigan, Jeanne Bicking, Mary S. Young, Theresa Francella Boylan, Nicky Anderson, Robert Kahler, and Wes Pannebaker.

I thank everyone who has aided in this production.

—Bruce Edward Mowday
January 2004

INTRODUCTION

Downingtown has been an important village in the history of Chester County, one of the original three counties of William Penn's Pennsylvania. The borough's location, between the important Colonial cities of Philadelphia and Lancaster, made the village an important stop for merchants during the early days of the United States. The Lancaster Road, known as part of Lincoln Highway and now called Lancaster Avenue, runs east and west through the middle of Downingtown and was a portion of the first turnpike in America, a toll road.

The East Branch of the Brandywine River, which bisects Downingtown, played a role in the development of the borough's manufacturing industry. Paper mills and mills of other types, along with additional businesses, used the Brandywine as a source of power. The Brandywine has not always been kind to Downingtown, as its banks have overflowed on a number of occasions, flooding many sections of the village. The borough hall, Kerr Park, the main intersection of Routes 30 and 322, businesses, and the homes of a number of citizens have all been inundated with water during floods.

The village predates the American Revolution and was used by the new Colonial government as a supply depot for Gen. George Washington's army during the Philadelphia campaign of 1777. On September 10, 1777 (the day before the Battle of Brandywine), one of Downingtown's leaders wrote the commonwealth's executive council to ask for a guard to protect the military stores. He also indicated he was asking for wagons from citizens to move some of the stores toward Reading, Pennsylvania. A regiment of the Pennsylvania line of Washington's army spent one winter of the war quartered in Downingtown.

Many important structures in the area have survived, including the historic Ashbridge House, which sits on the old toll road. Built in the early 1700s, the house is one of the earliest structures still existing in Chester County.

One of the pioneers of Downingtown was Roger Hunt. After marrying, Hunt built in the western section of the borough a house that was known as the Hunt mansion. A surveyor, he was reported to be involved in the design of Lancaster and, during the French and Indian War, served as a captain in the service of King George III.

One of the most recognized structures today in Downingtown is the building known as the Log House, which is situated on the north side of Lancaster Avenue near the Brandywine River and the Lancaster Pike Bridge. The bridge was constructed in 1802. Some historians have decreed that the Log House, built in the early 1700s, is where the community of Downingtown began. At first, Downingtown was known as Milltown. Thomas Moore built a corn mill in 1716, and the mill was one of the structures contributing to the name Milltown.

The first turnpike in America was constructed by the Philadelphia and Lancaster Turnpike Company, which was chartered on April 9, 1792. The road was completed in 1794 and was open to the public the next year. Public houses were constructed all along the road, averaging one a mile, to offer food and lodging for the teamsters and needed supplies for their animals.

Besides being a center for commerce, Downingtown was considered a perfect location for the seat of Chester County government. When Delaware County was split from Chester County in 1787, Downingtown was named as the prime community for the honor, but the village's citizens did not want to spoil their peaceful community by hosting the county government. The honor went to Turk's Head, now called West Chester, just a few miles south of Downingtown.

On January 27, 1859, a petition was filed with the Court of Quarter Sessions of Chester County to have the village of Downingtown incorporated as a borough. The request was approved on May 12, 1859. The borough's first chief burgess was James Lockhart, who held the post for two years. Downingtown's first postmaster was Hunt Downing, who assumed the role in 1798.

Downingtown has always been a close-knit community with many distinct ethnic neighborhoods, including the east and west ends and Johnsontown, which is located in the southwestern section of the borough. Downingtown's population has grown from 761 in 1860 to 2,133 in 1900 and 7,589 in 2000.

The borough hosts many different churches, including a Friends meetinghouse, attesting to the feeling of community in Downingtown. The town's fire companies have acted as centers for life in the community. Many festivals and parades are held throughout the year, including an annual Fourth of July celebration that draws thousands of visitors to the borough for a day of fun, games, food, and fireworks.

The community is proud of its schools. The public schools have increased from one high school to three; the public school system constructed a second high school, and Bishop Shanahan High School relocated from West Chester to Downingtown. The schools have a proud history for their academic, arts, and sports accomplishments.

One

THE EARLY DAYS

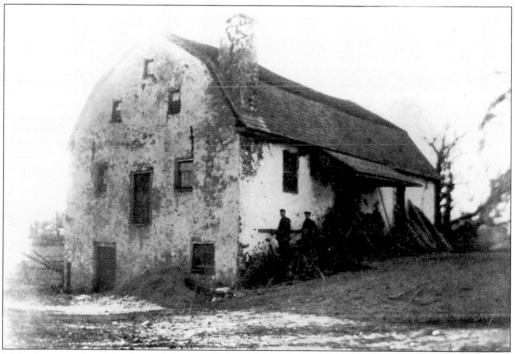

This photograph of the Roger Hunt mill was taken in 1890. Roger Hunt married Esther Aston, a member of one of the early Downingtown families, and constructed a gristmill along Beaver Creek. A miller's home was also built. The mill was completed in 1739, and the operation was one of the mills responsible for Downingtown's first name, Milltown.

Downingtown grew in its early days because of its location between the cities of Philadelphia and Lancaster and because the East Branch of the Brandywine River ran through the village. In the above photograph, a young girl sits in her carriage at the intersection of Manor and Pennsylvania Avenues. The image below shows the old tollhouse along what is now Route 322. The noted Chester County artist George Cope is said to have lived in the house.

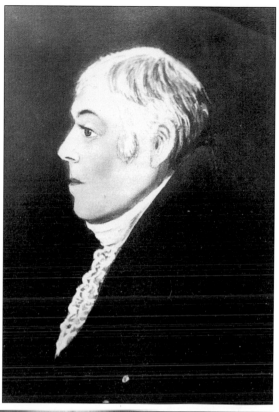

Many Downingtown area residents have taken active roles in local, county, and state government over the years. To the right is a rendering of Judge William Hepburn. One of the leading families of the early days of the community was the Bicking family. Taken in 1909, the photograph below shows women identified as "Aunt Hanna" (left) and Mary Parke Bicking, "Grandma Bicking," in the back parlor of their home.

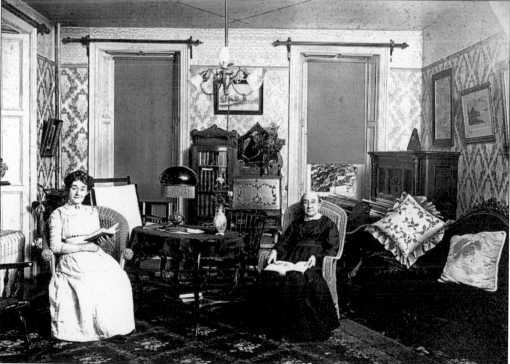

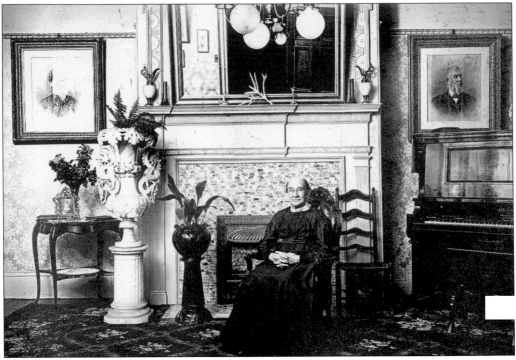

Seen above is the Bicking home front parlor, with Mary Parke Bicking seated before a fireplace. The Bicking homestead was located on Lancaster Avenue in Downingtown. In the photograph below, "Grandma and Grandpa Bicking" are seen sitting in the dining room of the Pennsylvania House, located in the 200 block of West Lancaster Avenue. Pres. James Buchanan visited the hotel when he was campaigning in the 1850s.

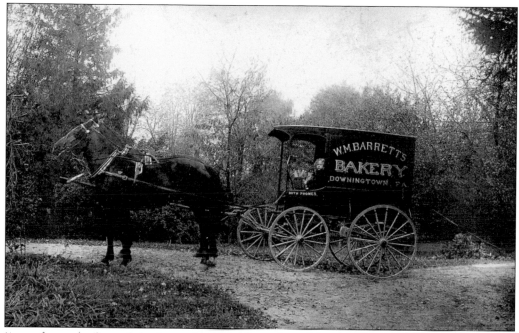

From the early days of the borough, a number of small businesses served the Downingtown community. In the above photograph, taken in 1908, a delivery wagon for the W. M. Barrett bakery is shown with Mildred Barrett, daughter of the owners, sitting in the wagon. Below, Daniel H. Zittle holds young Jane Chrissman Reynolds (born on April 5, 1908) in front of the D. H. Zittle paint and paperhanging store. The sign is for the Roosevelt Theater and a production of *The Sophomore* during the week of December 23.

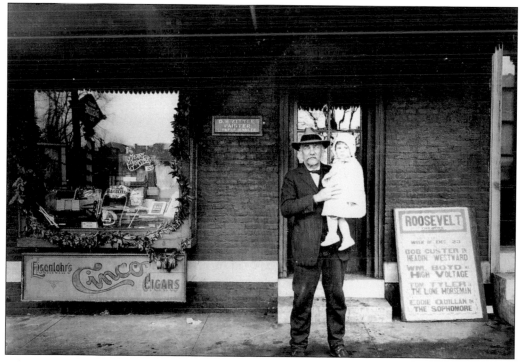

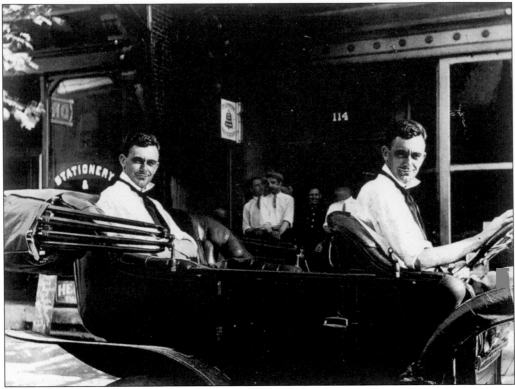

Early in the 1900s, the automobile came to Downingtown, as it did to most communities in the United States. In the above photograph, Clarence (left) and Paul Bicking take a ride while a number of Downingtown residents watch the Bickings as they drive away in the convertible. They are driving past a stationery store that is located on the borough's main street. Below, residents dress for a community celebration and crowd into an old automobile.

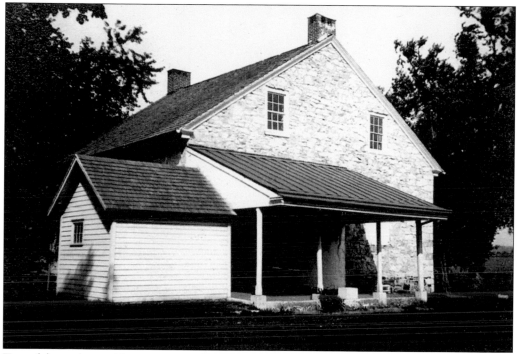

Two of the early notable structures in Downingtown were the Friends meetinghouse, on business Route 30, and the old Bell School, on the Downingtown Pike. Both of the photographs were taken in July 1902. The permanent meetinghouse for Downingtown was constructed in 1806, when Peter Sheneholt, an East Caln mason, was hired to construct the building. The Quakers had a strong influence on Downingtown even before the meetinghouse was built.

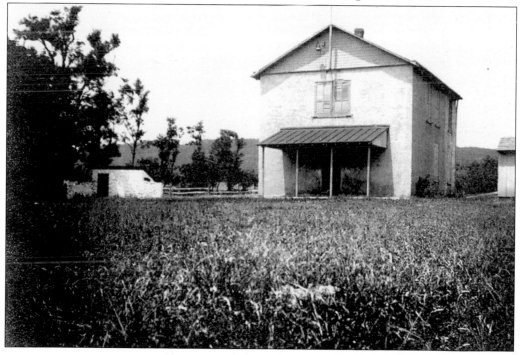

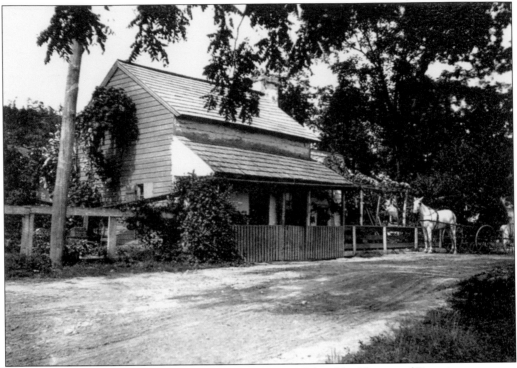

As part of a series of July 1902 photographs, two pictures of the old tollhouses of Downingtown were taken. Above is the tollhouse on the Route 322 curve; below is the tollhouse where Shepherd Ayars was the toll taker as early as 1857. The first toll road in America ran though Downingtown.

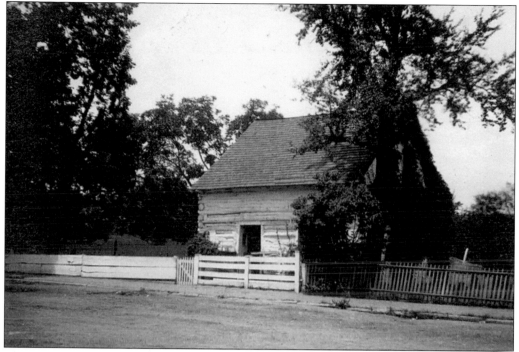

The oldest structure in Downingtown is the Log House, built in the early 1700s. It was moved in the late 20th century to protect it from the deterioration resulting from vehicle traffic on Lancaster Avenue. These July 1902 photographs show the Log House, above, and the Downingtown National Bank, below. The bank site once housed Jacob Edge's store and the town's library.

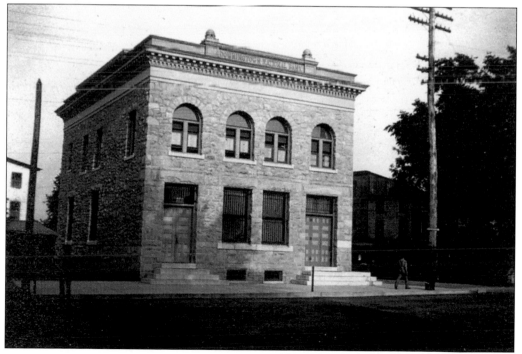

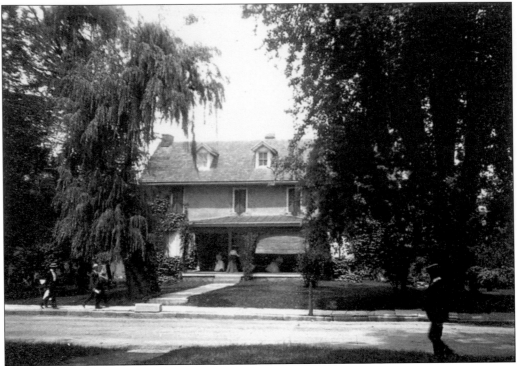

The David Shelmire home, seen above, was constructed in 1723. It has long since disappeared, and a McDonald's restaurant now occupies the site. Another building that has disappeared from the town's landscape is the Shelmire Grist Mill, seen below. It was also built in 1723. The photographs are part of the July 1902 series.

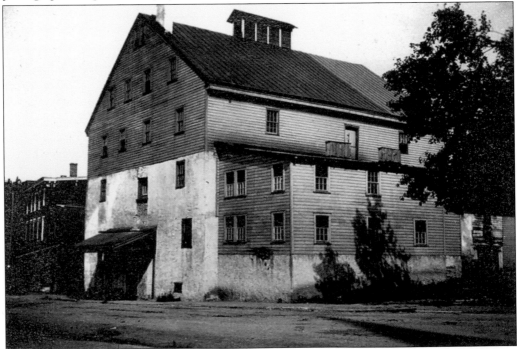

Two early structures in the middle of town were the Central Presbyterian Church, to the right, and the Charles Ziegler and James Lockhart homes, below. The Lockhart home was located east of the stables of the old Swan Hotel and was torn down for a parking lot. The Central Presbyterian Church building is now used for the Dane Décor furniture store. Both photographs are part of the July 1902 series.

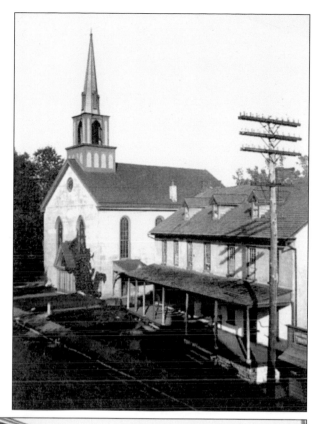

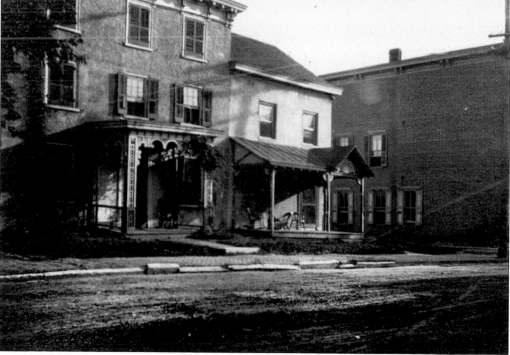

Shown above is the former home of Harvard Downing, on Lancaster Avenue near St. James Episcopal Church. Below, J. Harvard Downing is testing a fire hose at Washington Avenue near Brandywine Avenue. The photograph above was taken on July 22, 1902, and the testing of the fire equipment took place on July 15, 1902. Downing was one of the leaders of the Minquas Fire Company when it was formed in 1908.

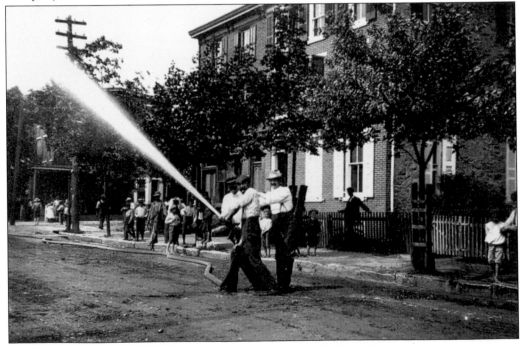

The home of Richard I. Downing, seen above, was constructed in 1723 and was located north of where the Bell School was later built. Downing was the first son of Thomas and Thomazine Downing. Capt. James Lockhart's stable (below) stood on Forge Road behind Lockhart's store. The road is now known as Wallace Avenue. The photographs are part of the July 1902 series.

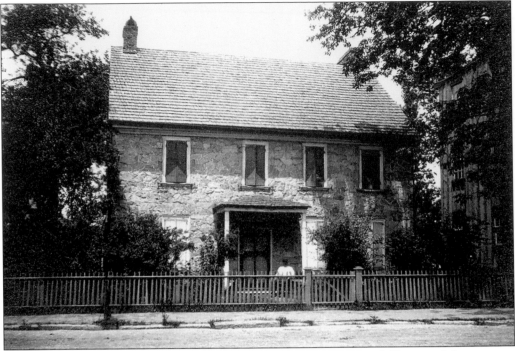

Two more homes of the Downing family are on this page. Lawrence J. Downing's home, seen above, is believed to have been located next to the Log House. It has since been torn down. The home of William W. Downing, below, stood on Park Lane. The structure was once the Evan Thornburg blacksmith shop. The photographs are part of the July 1902 series.

Two

COMMUNITY LIFE

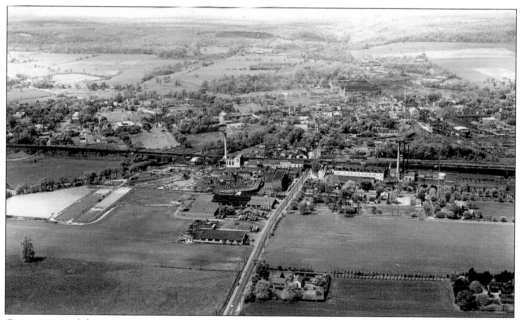

Community life in Downingtown has revolved around various civic organizations, church congregations, and businesses large and small. As seen in this 1940 photograph, taken looking north from the High Railroad Bridge near Route 322, Downingtown spreads east and west along another set of railroad tracks and Lancaster Avenue (also known as business Route 30 and Lincoln Highway).

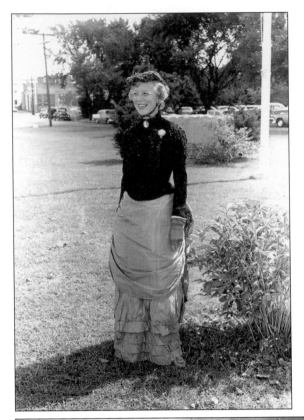

Residents have taken part in a number of community celebrations over the years, and they have always liked to dress in period costumes. The woman shown to the left is dressed for a celebration of Downingtown's 100th anniversary, and the women below are members of the Mothers' Club of West Ward School. They are Betty Mangy, Ginny Henry, Harriet Ash, Sue Rodgers, Edna Ross, Marian Simmons, Marion Holl, Emily Lewis, Louise White, Jean Priest, Caroline Hadfield, Margaret McCombs, and Iby Entrekin.

The men waiting for dinner above are executives of the Downingtown Paper Company at a management and supervisory meeting in 1945. The photograph below is labeled, "Friendship Circle of the Sunday School Class of Central Presbyterian Church." It was taken on December 16, 1947, during a Christmas dinner at the Downingtown Tea House.

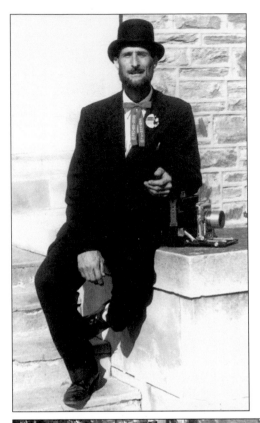

Photographer Alfred Giannanino memorialized many of the Downingtown celebrations in the mid-20th century. He is shown to the left during the Downingtown centennial. The photograph below was taken by Giannanino and shows a Pepperidge Farm wagon created for the centennial celebration. Included in the photograph are Mary McCombs, Phyllis Cozzone, Mary Law, Frank Saella, Angie Moschitts, Dot Mulkin, Helen Powell, and Helen Shoemaker.

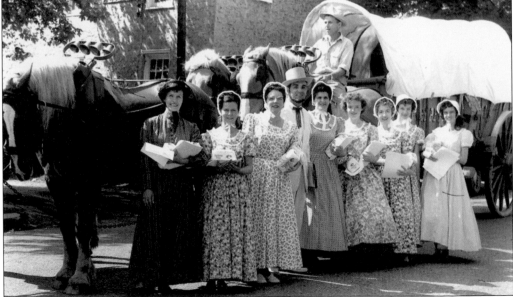

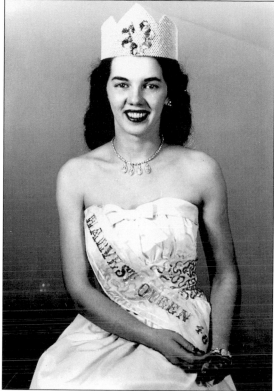

The harvest queen is shown to the right in a photograph taken by Alfred Giannanino in 1948. The photograph below shows the chamber of commerce float during Downingtown's centennial celebration. The picture was taken by Giannanino on Lancaster Avenue near the intersection of Route 322, the road to West Chester.

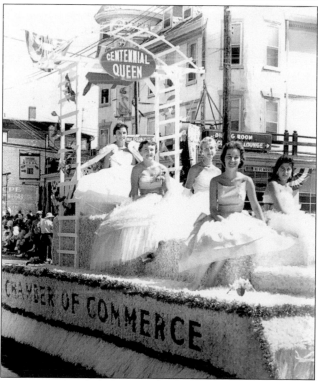

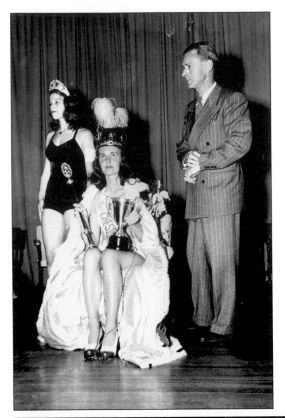

The two pictures on this page could be photographer Alfred Giannanino's version of beauty and the beasts. The photograph to the left was taken at the Miss Chester County contest in Downingtown in the late 1940s; the photograph below shows a number of the borough's leaders taking off their beards as part of Downingtown's centennial celebration.

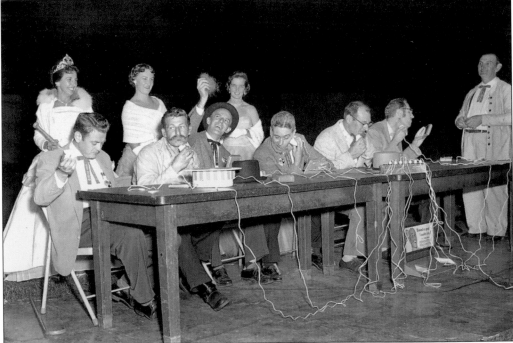

The Bicking family is one of the leading families of the borough. Shown posing at the bridge in Downingtown is S. A. Bicking. The name S. Austin Bicking shows up a number of times on the family tree. One started the first paper mill in Downingtown. Another appears in the records as a tailor, and a third S. Austin Bicking fought in World War I.

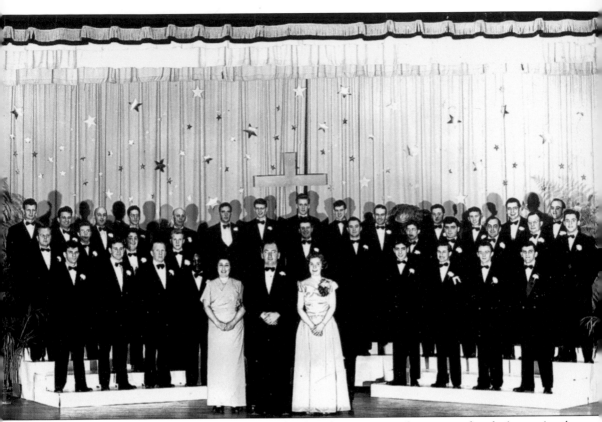

The stage of the Downingtown High School auditorium was the scene of a show on April 13, 1949. Walter Show took this photograph. From left to right are the following: (first row) Margaretta Helms, Ed Irwin, and Gerry Swarner; (second row) Joe Travaglini, John Shistler, Talbert Swarner, Earl Thomas, Leo Ciarlone, Peter Short, Clarence Miller, and John Travaglini; (third row) Morris Stevens, John Rihier, Jim Zaferas, Ron Piersol, Hathaway Frain, Fritz Bicking, Marv Frederick, Dan Massimini, Alan Hughes, Roger Bender Sr., and Roger Bender Jr. In the fourth row are Nels Norris, George Ciarlone, Gordon Carpenter, William Ash, Herbert Pritchard, Gibson McIlvaine Shuman, Ron Hogg, Harvey Young, Wilson Pollock, Gordon Carpenter Jr., John Windle, William G. Barrett, Robert D. Laird, and an unidentified man.

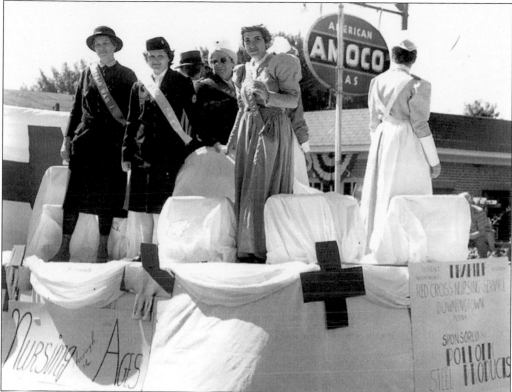

Residents participating in the Downingtown centennial celebration represented many aspects of life through the ages in the borough. The photograph above, taken by Alfred Giannanino, shows women wearing nursing uniforms from different periods. To the right, a couple is strolling through Kerr Park in Downingtown. The man is wearing a top hat; the woman, a dress of the 1800s.

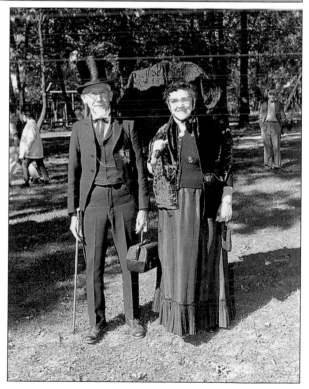

The Downingtown Opera House, on Brandywine Avenue, was the setting for many different performances by many entertainers. Above, the opera house is the structure in the center of the photograph. The photograph below shows the interior of the building, which included a balcony. The crowd is enjoying a show. The building was later used for a commercial business.

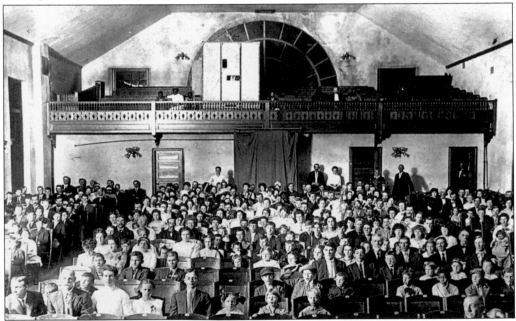

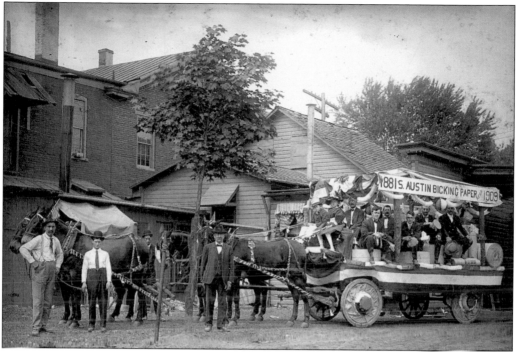

Many celebrations were held in Downingtown in the 1900s. The photograph above shows the S. Austin Bicking Paper float and records the dates 1881–1909. Downingtown has had several mills along the East Branch of the Brandywine River; the Bicking mill was the first one in the borough. The photograph below shows, from left to right, John Parke, Kathryn Ruyon, Jane Hutchinson, and Frank W. Bicking during a Liberty bond sale in the old Weldon Building during World War I.

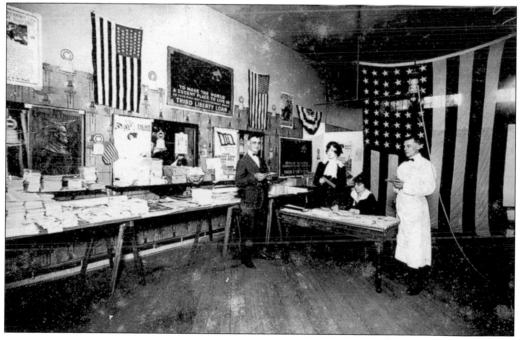

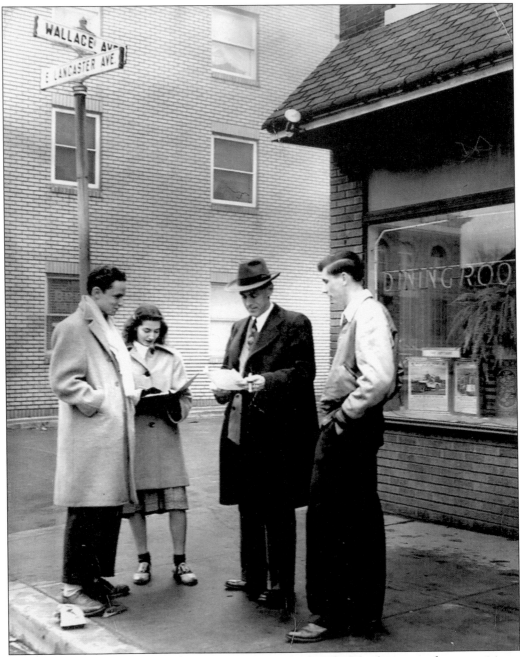

One of the qualities that makes Downingtown special is the involvement of young citizens in the borough. In this photograph, high school principal Leo Hamilton is talking with three student leaders of the high school during the 1940s in front of one of the borough's restaurants at the corner of Wallace Avenue and East Lincoln Highway. Hamilton served the borough in a number of capacities. As chief burgess during World War II, he was authorized by borough council to establish rules to regulate air-raid drills and govern blackout plans against possible air attacks. He was also involved in the formation of the local Babe Ruth baseball team and received the 1952 Distinguished Civic Award from the local chamber of commerce.

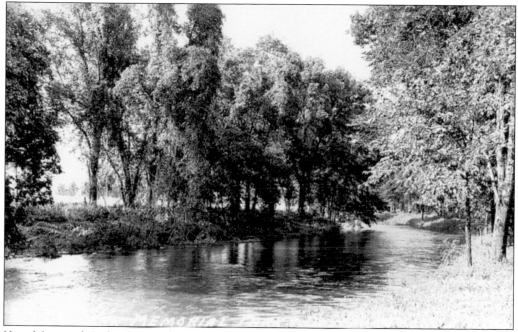

Kerr Memorial Park, shown above, has been used for many civic gatherings over the years, including the base for the Fourth of July celebration and fireworks show. The park was created by the Business Men's Club in the 1920s, east of the East Branch of the Brandywine River and running along both sides of Pennsylvania Avenue. The photograph below was taken in September 1940. From left to right are Mrs. Arthur Phillips, Mrs. Elmer Schrumpf, Elmer Schrumpf, W. I. Pollock, Jacob Habocker, Herbert Ash, Walter Phillips, and William Backenstose.

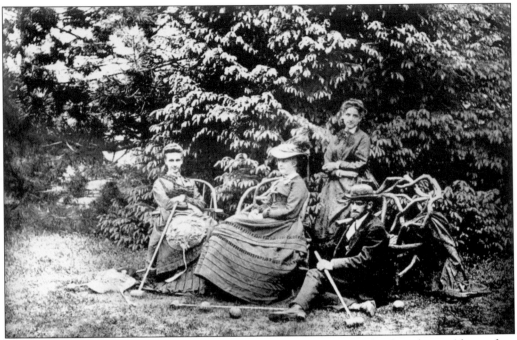

Recreational pursuits can take place in Kerr Park or in the backyards of residents. Above, four residents are taking a break from a game of croquet. The photograph was taken by John C. Bromie in May 1871. The photograph below shows a 1918 dinner meeting in Downingtown. The American flags, including the naval one on the far wall, indicate a connection to the conclusion of World War I.

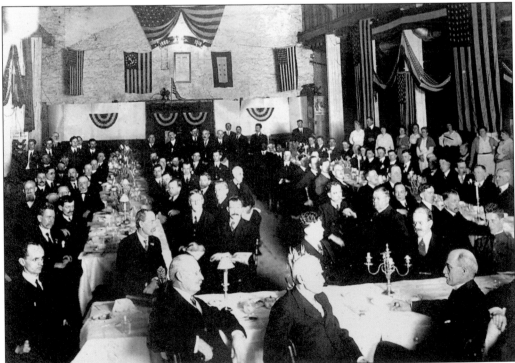

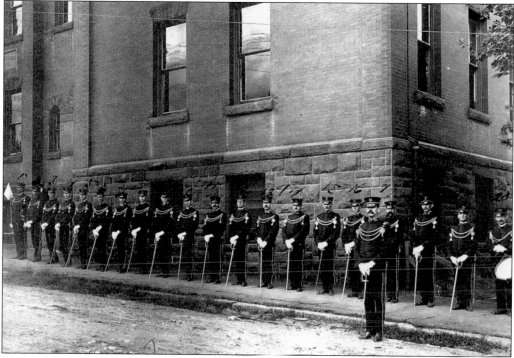

The Washington Camp 338 of the Patriotic Order of the Sons of America was active in Downingtown during the early part of the 20th century. The photograph above, taken in 1908, shows 22 members in full-dress uniform before a Pennsylvania Camp parade. The photograph of the Downingtown unit might have been taken in Hazleton, Pennsylvania. Below, members are relaxing before playing a game of baseball.

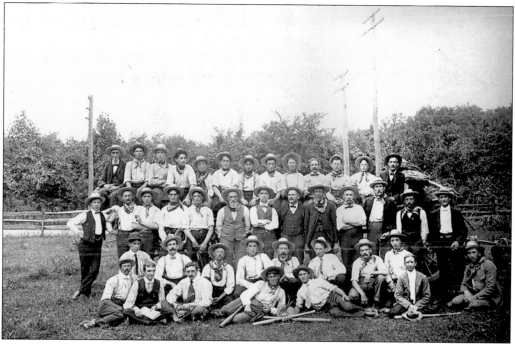

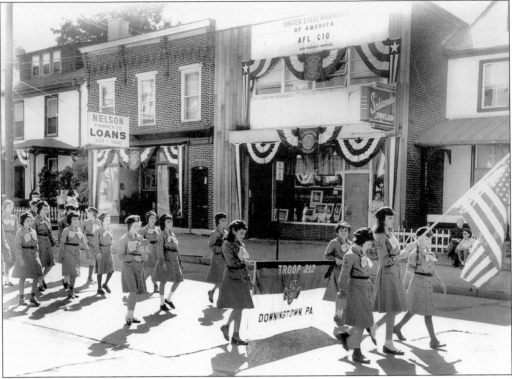

During the Downingtown centennial parade, Troop 212 of the Girl Scouts of America marched down Lancaster Avenue. The scouts are shown above as they pass in front of the old United Steel Workers of America AFL-CIO subdistrict office, near the Nelson Finance Company. Below, a large Downingtown area family gathers for a reunion and picnic.

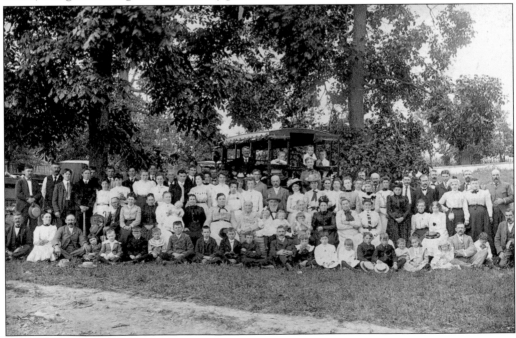

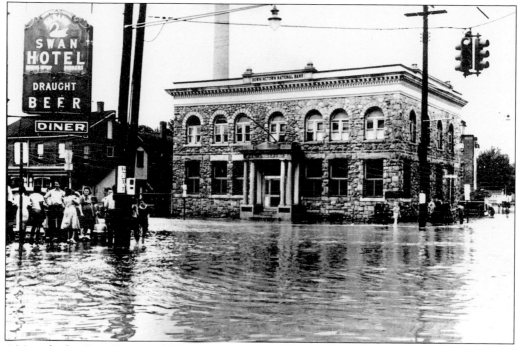

Although the East Branch of the Brandywine River supplied power for Downingtown's early mills and offered scenic views for relaxation, it has also flooded the borough on many occasions. These photographs show the flooding on August 9, 1942. Above is the high-water mark around the Downingtown National Bank, at Lancaster Avenue and Route 322. The photograph below shows Park Lane in front of the old Sheeler's Garage.

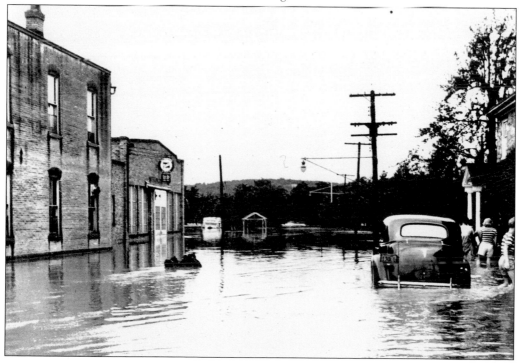

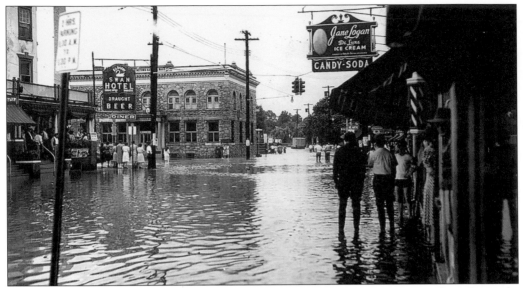

The August 1942 flood is shown in these two images. Above, one group stands in front of a barbershop next to a restaurant with a sign for Jane Logan ice cream. The second group is in front of the old Swan Hotel, which (according to the sign) offered food and served draught beer. In the photograph below, three men in swimming trunks are guiding a boat along Brandywine Avenue.

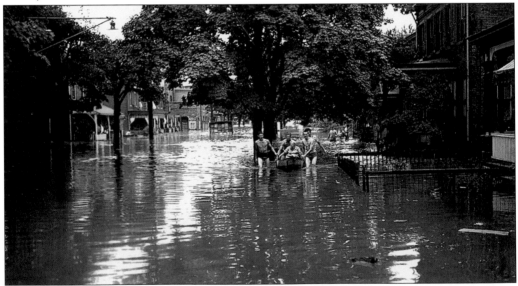

Three

SCHOOL LIFE

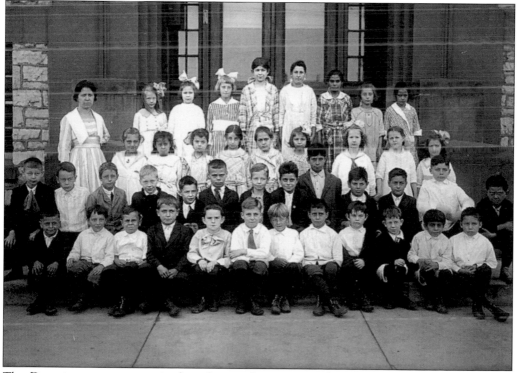

The Downingtown community has always taken great pride in its schools. Besides excelling in academics, the schools have a history of being successful in sports. Shown in this c. 1930 photograph is the West Ward School class of teacher Sara Way (standing to the left).

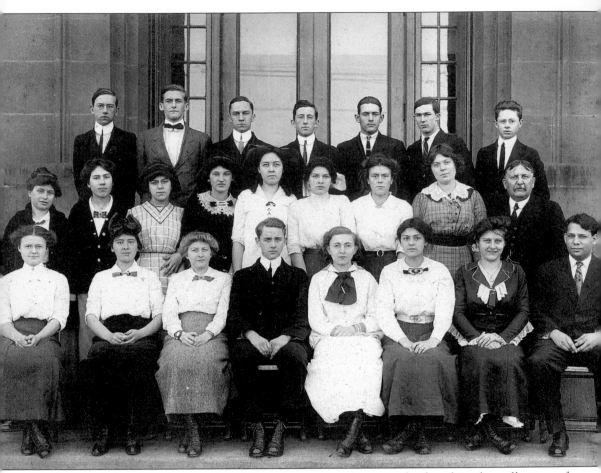

Many of the class photographs of Downingtown students can be found in the collection of the Downingtown Area Historical Society. Pictured here is the Downingtown High School graduating class of 1914. The names of the students have been written in pencil on the back of the photograph. From left to right are the following: (front row) Mary Dowlin Frain, L. Styler, Mary S. Darlington, Howard B. Simmons, Anna Stoneback, Helen Hess Howe, Stacy Peters, and unidentified; (middle row) Irma Hess Worrall, Christy Fleming, Margaret Pecket Phillips, Sadie Williams, Anna Hughes, and John R. Hunsicker; (back row) David Ballentine, Aubrey Hartman, Leland Wilson, John Davis, John MacDonald, Edgar Powell, Warren Johnson, Maurice Thomas, and Jessie Larkin Rogers.

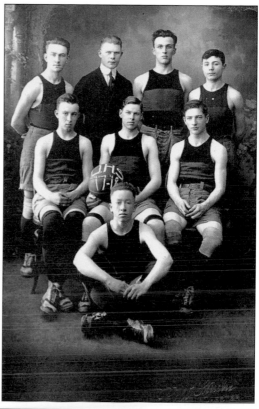

These two picture postcards feature Downingtown athletes. To the right is the Downingtown High School boys' basketball team of 1917–1918. In front is Elmer "Babe" Davis. The others are, from left to right, as follows: (front row) Frank McLain, Hathaway Frain, and John Francella; (back row) Lowell Fisher, coach Joe Donahue, Wilmer Dolbey, and Charles Cain. The people seen below are unidentified. The two postcards are from the same year.

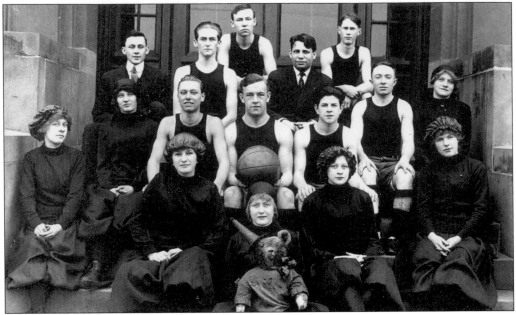

The postcard above includes athletes from the images on the preceding page. No identifications are given, but the faces look the same and the dress and the bear mascot are the same as those in the other postcards. Below is the West Ward School class of Anna Charles Campbell. She is standing by her students in the back row. The photograph was taken c. 1930.

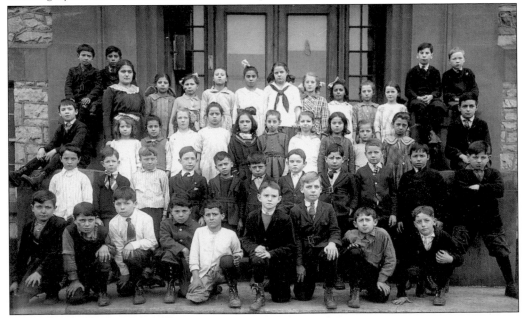

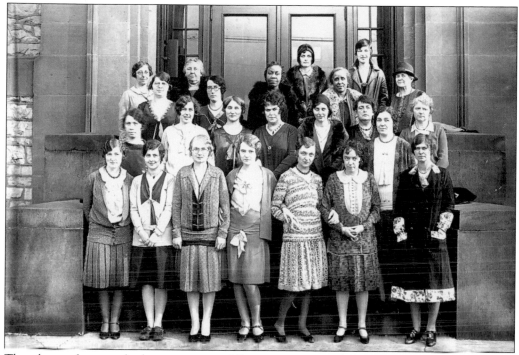

The above photograph shows a group of Downingtown teachers. From left to right are the following: (first row) M. Miller, Henretta Touchton, Ruth Shumway, Winifred Gumble, Sara Rodeback, Rhoda Yost, Sara Brown, and Pat Bush; (second row) Lillian Perry, Dorothy Schubert, Sara Powell, Alice Hadfield, Elizabeth Ezrah, Anna Holl, and ? Gray; (third row) Irma Grier, Helen Wack, ? Washington, ? Gibbs, and Mary R. Swayne; (fourth row) ? Matlock, ? Freeman, Betty Carmichael, and Ida Lillard. Below is the second-grade class of East Ward School for the 1950–1951 school year. Ruth Lowe, who contributed to this book, is in the center of the back row.

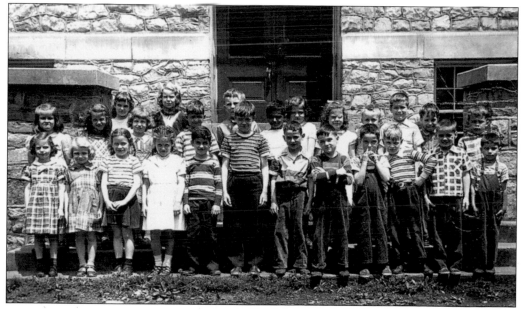

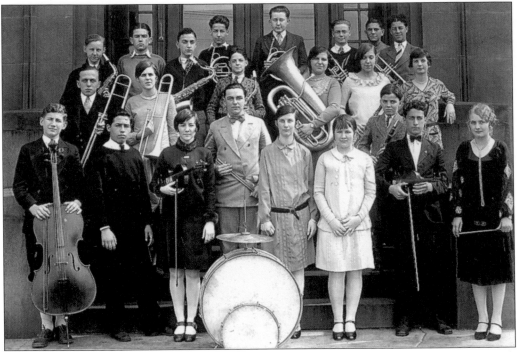

Besides sports, Downingtown students excelled in music and the arts. The above photograph shows the Downingtown High School orchestra of 1929. The members are David Heilig (bass violin), John Francella (violin), Mary Jane Kehler (violin), James Fennelly (drum), Leta Tweed (drum), James Elston (clarinet), George Ciarbone Jr. (violin), Ruth Shumway (director), Horace Moore (slide trombone), Marion Laird (slide trombone), William Ash Jr. (saxophone), L. Bicking (saxophone), William Pollock (saxophone), Horace Hutchison (saxophone), Leroy Pawling (French horn), Jack Lampany (French horn), James Mohan (cornet), and Joseph Sciaretta (cornet). Below is the 1923 Downingtown High School football team.

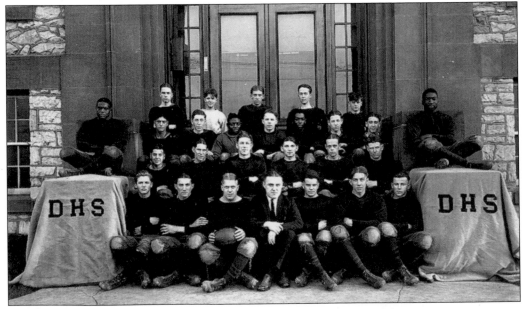

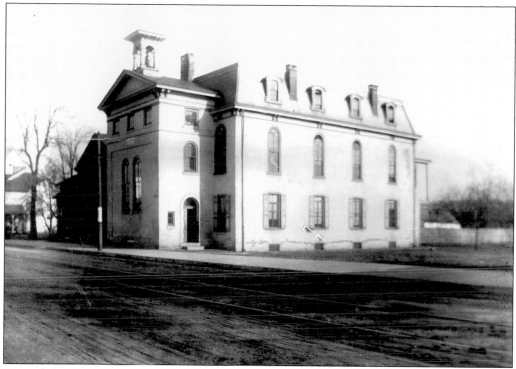

Two of the important school buildings in the Downingtown school system were the West Ward School, above, and the old high school on Manor Avenue, below. At one point, the Downingtown High School, later known as the West Ward School, was one of the few schools in the area offering classes beyond the eighth grade. Land was purchased from W. I. Pollock and his son for the construction of a new junior and senior high school on Manor Avenue.

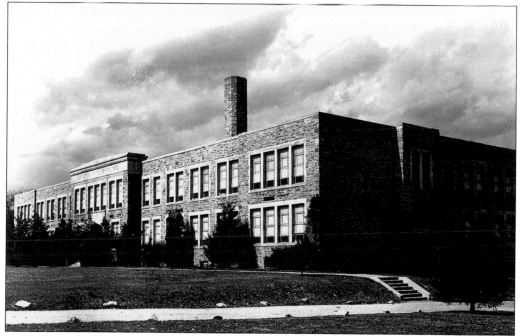

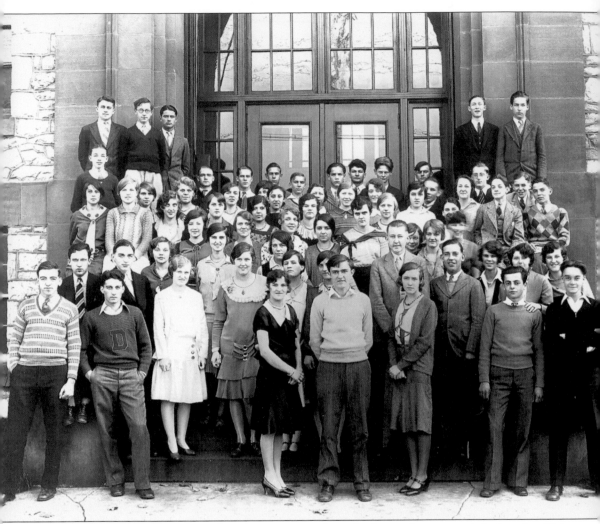

The number of students in the classes increased as the borough prospered during the 20th century. This photograph shows the members of the junior year class of 1932 at the high school. Included in the photograph are Morris Speakman, George Ciarlone Jr., Isabel Loray, George Stone, Abel Dennis, Michael Mento, Edwin Mendenhall, S. Kauffman, Horace Hutchinson, Elizabeth Wein, Mary Barefore, Q. Rossi, Jack Lamping, Charles Elston, Lois Henry, Thelma Esworthy, Ruth Pannebaker, Virginia McMichael, Dorothy Phillips, Dorothy Detterline, Dorothy Diffenderfer, Abie Wray, Mary Jan, Ruth Reaber, Rose Runk, Elizabeth Beitler, H. Thomas, Esther Miskelly, Ann Pontius, A. Pontius, Lillian Bareford, Helen Fahey, Ann Fahey, Elizabeth Carpenter, Elinor Levenite, Eileen Farrell, Mary Jane Hutchinson, Emma Goltier, Elsie Hashinger, Geraldine Harper, Edith Duca, Gertrude Kaplin, Helen McLain, Anna Wise, Morris Seeds, Margaret Wisth, Robert Amway, William Ash Jr., Arthur Harrison, James Elston, Francis Fennelly, Horace Schwetze, James Hunt Jr., John Cathus, Jim Summers, Norman Piersol, John Kaempher, William Larken, Dave Daylor, and LeRoy Powling.

Students in Sue Byler's class are shown above working on a problem. The only student identified is Howard B. Simmons (in the corner). Below are members of the West Ward baseball team. Only some of the members are identified: Donald Dixon, Dan Jefferies, Ed Watson, Harry Deets, Merle Brown (coach), Joe Mento, Blaine Harkness, J. Pawling, Tom Deets, Mike Mento, and George Stine.

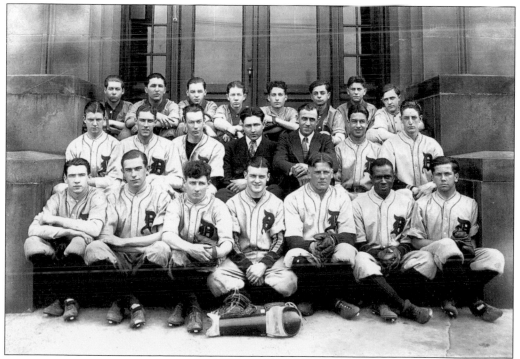

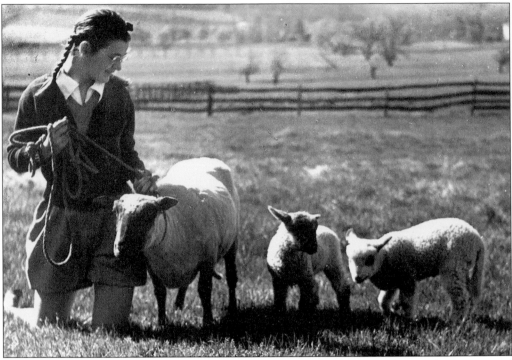

Students in the Downingtown area did not spend all of their time studying, playing musical instruments, and participating in sports. Mary Louise Lloyd, another member of an early Downingtown family, is shown above tending to sheep and lambs. Seen below is a Downingtown school basketball team.

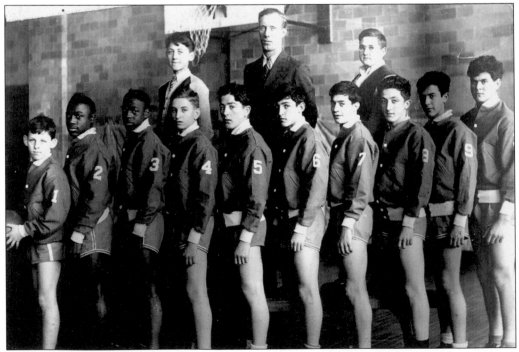

Four

BOROUGH BUILDINGS

Downingtown has always had a strong religious community of numerous dominations. The old Baptist church is pictured here. The history of the Baptist congregation in the borough dates from 1883, when it was organized with six members. The church quickly grew, and within a year, the reported average attendance at the Baptist Sunday school was more than 100. In 1886, a plot of land was purchased at the corner of Manor and Lancaster Avenues for the building of the church.

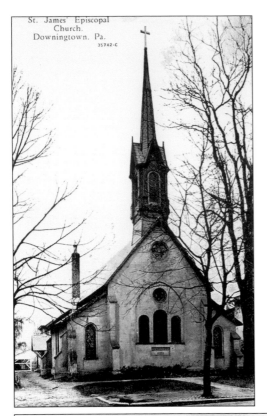

St. James' Episcopal
Church.
Downingtown. Pa.
35742-C

Two other churches of the borough are
depicted in picture postcards on this page.
In the postcard to the left is the St. James
Episcopal Church. Below is the Methodist
Episcopal Church of Downingtown. The first
services of St. James in Downingtown were
conducted in the early fall of 1842 by
Rev. Gregory T. Bedell. The first recorded
Methodist services in Downingtown were
held in 1824. Before the church was built,
gatherings took place in private houses and in
a wheelwright shop near one of the tollhouses.

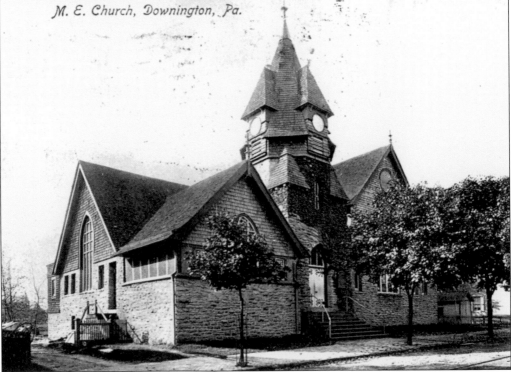

M. E. Church, Downington, Pa.

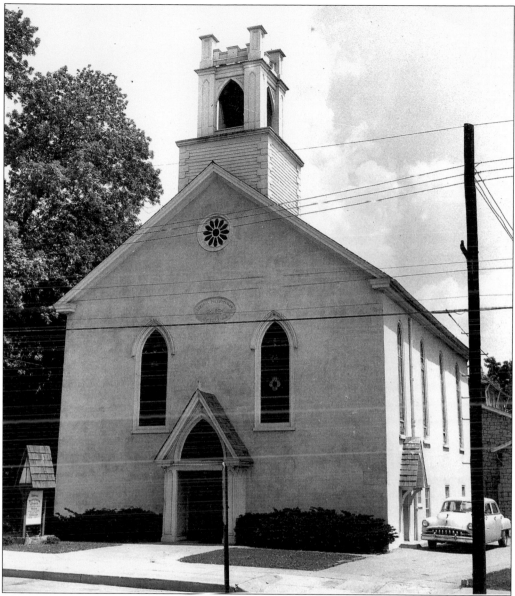

The Central Presbyterian Church in Downingtown has a long history. The building pictured on this page was used by the congregation until a new church was constructed along Route 113 in the eastern end of the borough. The old church building was sold and now houses an upscale furniture store, Dane Décor. The beginnings of Presbyterianism in the borough had two factions, known as the Old School and the New School Churches. The groups separated in 1837 because of differences in doctrines and the administration of the benevolences. A reunion did take place in 1869. A Presbyterian pastor from East Whiteland Township began teaching in various locations, including a public schoolhouse and a local merchant's yard, in 1843. The charter for the church was granted in 1862.

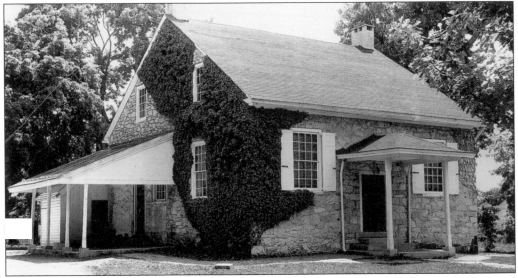

The Society of Friends was one of the first religious groups to preach in William Penn's original three counties, and a group was organized in Downingtown in 1807, some 100 years after meeting in neighboring Uwchlan. In 1784, occasional services were held in Downingtown. The opening of the Downingtown Preparative Meeting was reported to be March 27, 1811. The photograph above shows the Downingtown meetinghouse, and the image below features the sheds on the property.

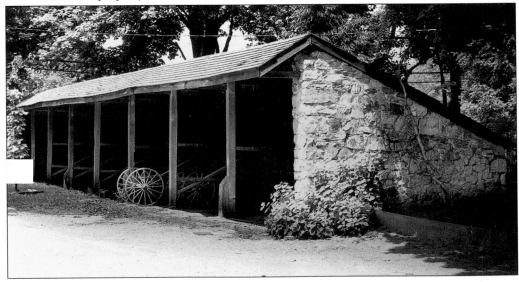

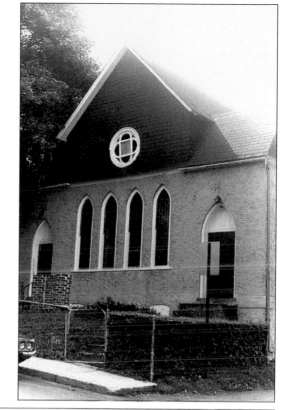

The churches on this page are the ones predominantly patronized by the Downingtown African American community. The church to the right is the Bethel African Methodist Episcopal Church, and below is the Mount Raymond Union American Methodist Episcopal Church. The latter stands at the corner of Stuart and Manor Avenues, and a Sunday school was first organized in 1874.

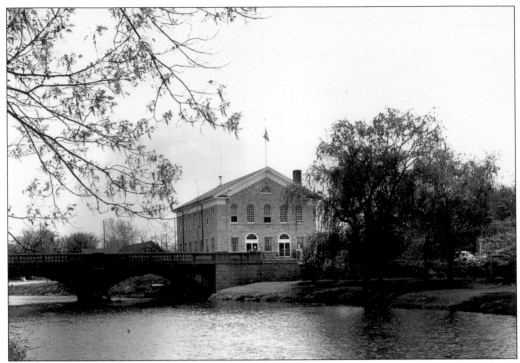

One of the most recognizable buildings in Downingtown is the borough hall, seen above. It sits on the banks of the Brandywine River near the Brandywine Bridge, seen below c. 1900. The original Lancaster Avenue Pike Bridge was constructed in 1802, and a new bridge was built in 1921.

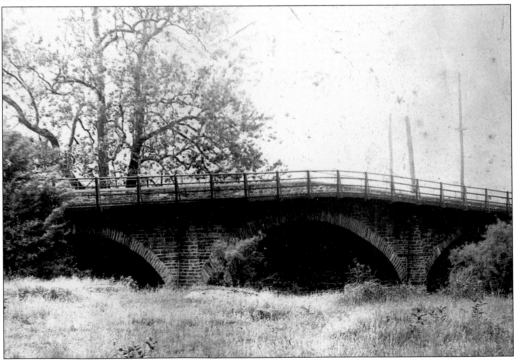

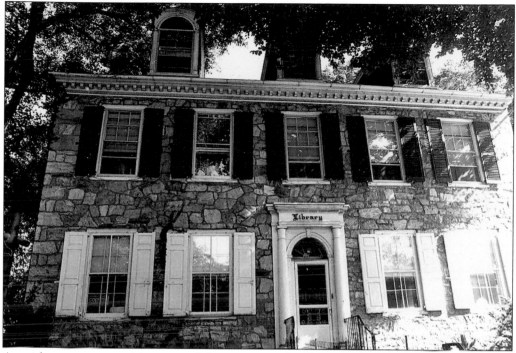

As with most communities, one of the important buildings in Downingtown is the library, shown above. The building, located on Lancaster Avenue, first housed a boarding school run by the Thomas sisters in the early 1800s. The library has served thousands of patrons each year. The photograph below shows the home of Charles and Louise Bruton. Charles Bruton was one of the town doctors in the early 1900s.

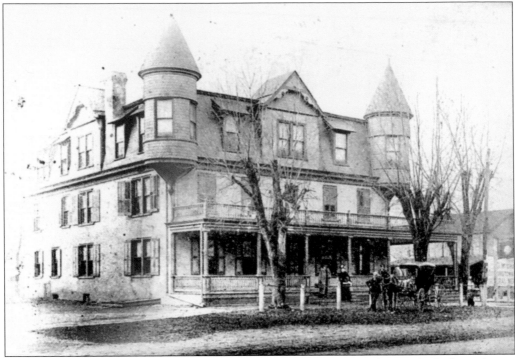

For years, the Swan Hotel was a major building in Downingtown. Thomas A. Parke, a former school administrator, owned and operated the Swan Hotel and tavern. The property for the hotel was a large segment of land that extended from Lancaster Avenue to Boot Road, along Route 322. The hotel at times also rented space for local businessmen. The photograph above shows the Swan Hotel at the beginning of the 20th century; the picture below shows the hotel in the later years, before it was torn down.

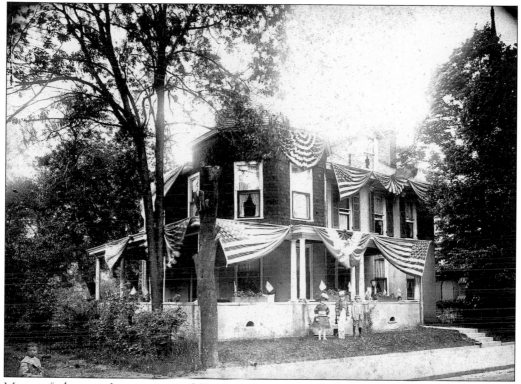

Many of the stately mansions of Downingtown were decked out with flags for patriotic celebrations. The photograph above shows the Bicking family home, which is adorned with flags and bunting. There are also flags in the flower boxes. Note the children in costume, including a small version of Uncle Sam. The photograph below also shows one of the old borough homes, with a gathering on the font steps. The building, located on West Lancaster Avenue, later housed an insurance agency.

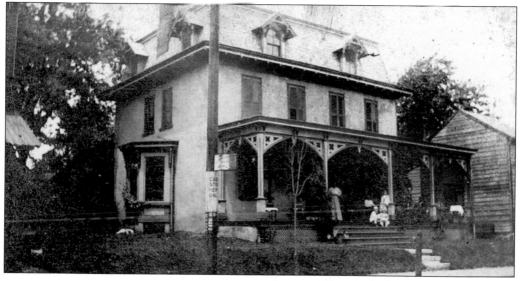

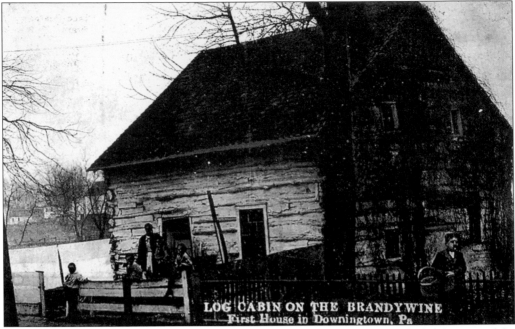

LOG CABIN ON THE BRANDYWINE
First House in Downingtown, Pa

The Log House, located on Lancaster Avenue in the middle of the borough, has been used for historical and tourism purposes in recent years, but it was also home to a number of families. The picture postcard above shows members of the Boggs family posing in front of their home. The building shown below was home to Dr. L. T. Bremmerman and his family. It is decorated for a borough celebration in 1909.

The snowy winter scenes in Downingtown can be beautiful. In the above photograph, a blanket of snow decorates a home on Downing Avenue in the borough. In the Johnsontown section of Downingtown was the Irish Catholic Benevolent Union. The Johnsontown section (the southwestern part of the town) housed a number of important buildings, including St. Anthony's Lodge. The yearly Frog Legs dinner at the lodge drew large crowds from across Chester County.

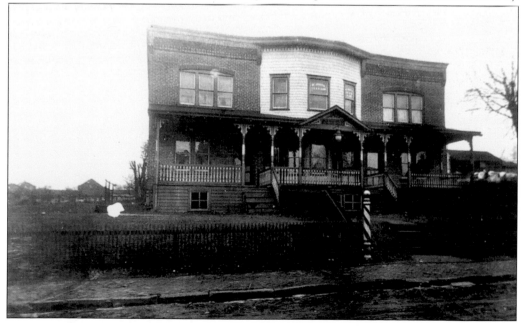

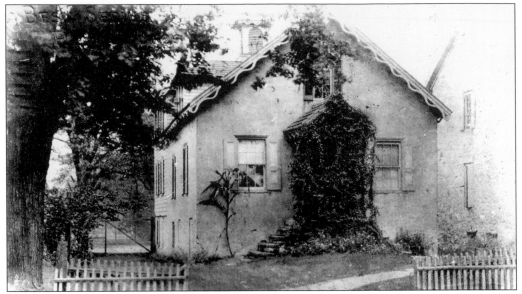

As communities change, structures either change in appearance or disappear. Above is a view of a building with a picket fence and a vine-covered porch on Lancaster Avenue. Such a sight cannot be seen in modern-day Downingtown. The building was used as a library. In the photograph below is a building surrounded by trees. It is one of the old tollhouses. The photograph was taken in 1902, and the structure no longer exists.

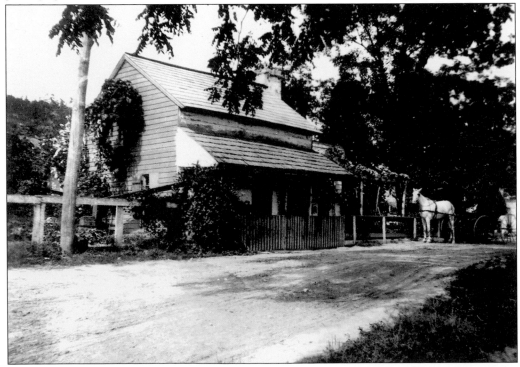

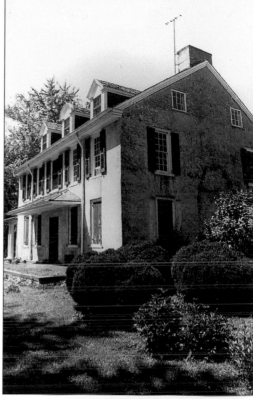

Seen to the right is a side view of the old Lloyd home. A member of the family, William Lloyd, took part in community committees, including one in the 1930s affiliated with the Work Projects Administration (WPA). The photograph below was taken in July 1902 and shows the old Samuel J. Downing home. Members of the Downing family were active in the development of Downingtown since the founding of the borough.

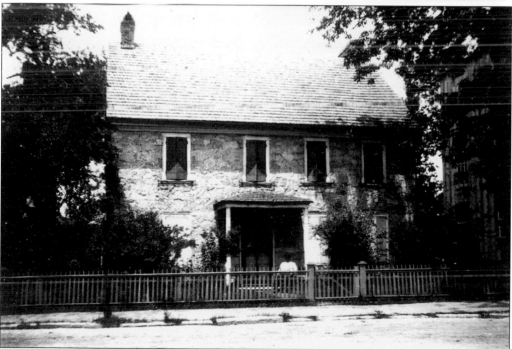

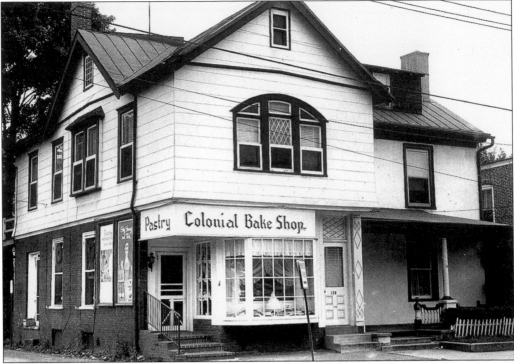

Buildings that have been prominent over the years in Downingtown have been used to house retail businesses. The photograph at the top of the page shows the Colonial Bake Shop, where sweets were sold for many years to the borough's residents. The bottom photograph shows the old B. Frank Davis store. The building has been transformed somewhat and now holds the popular Coffee Cup restaurant.

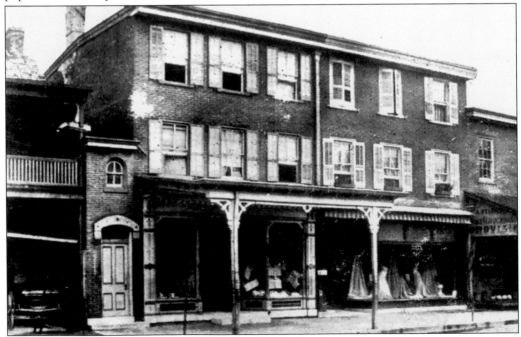

Five

BOROUGH BUSINESSES

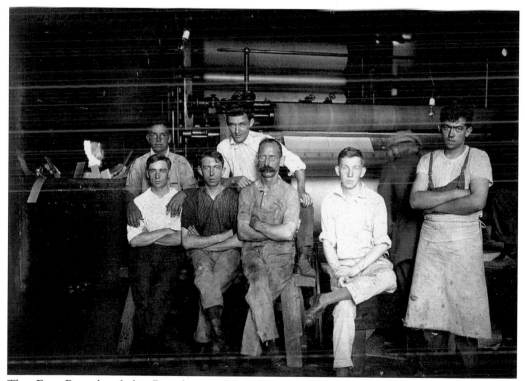

The East Branch of the Brandywine River has supplied power for one of the important industries of Downingtown, the paper mills. This *c.* 1910 photograph shows workers of the Frank P. Miller Paper Company. The business was later known as the Downingtown Paper Company and later became a division of Sonoco Products. Miller was involved in the founding of the Downingtown Manufacturing Company in 1881.

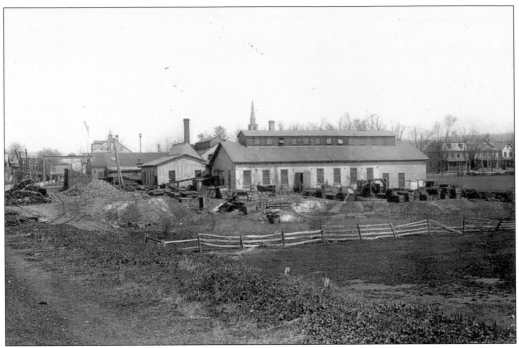

The photograph above shows the old Downingtown Manufacturing Company building. Frank P. Miller, along with A. P. Tutton and Guyon P. Miller, founded the company in 1881. The Miller brothers had previously operated a machine shop. Seen below is the old Bill Hess restaurant on Brandywine Avenue. The restaurant received extensive damage from the flood of August 8 and 9, 1942.

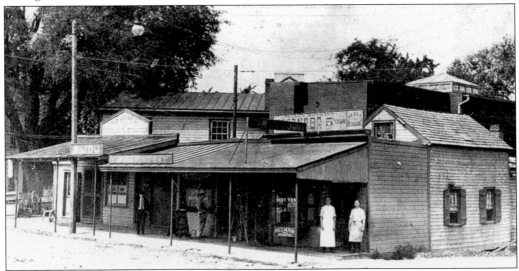

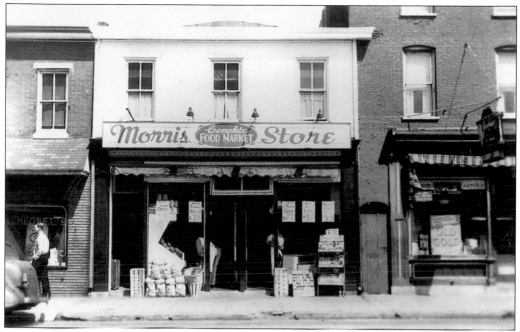

Before the days of the gigantic chain food stores, residents purchased provisions at local businesses. The Morris store was one such establishment in Downingtown. Above, a sign on the building says the store is a "complete food market." The photograph below shows the interior of the market, including the refrigerated and vegetable sections. An old scale hangs from the ceiling. Apples were selling that day for 29¢ a pound.

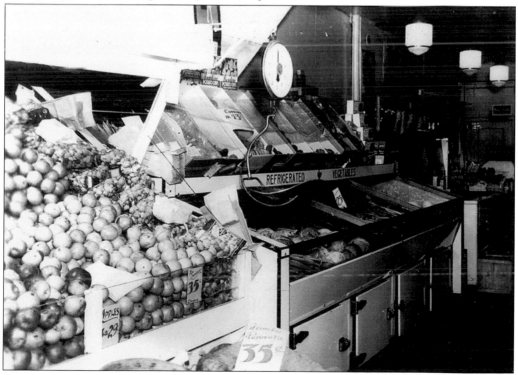

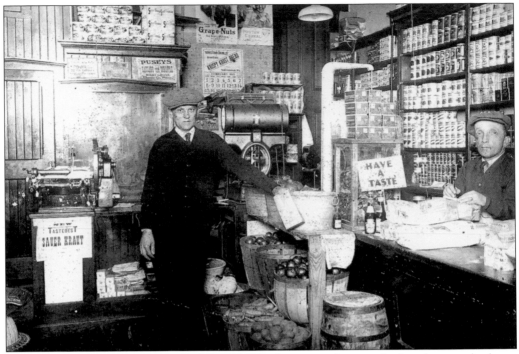

The Bicking Food Store was located at 135 West Lancaster Avenue. In the photograph above, Matt Myers (left) and Frank Bicking are shown c. 1925. Bicking is also shown below c. 1929 or 1930. The store carried many products, including a display of sauerkraut. There are also signs for Grape Nuts and Krispy Krust bread. A sign reading, "Have a Taste" is above a bottle of some sort.

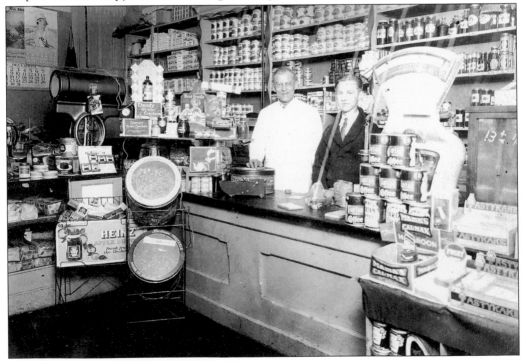

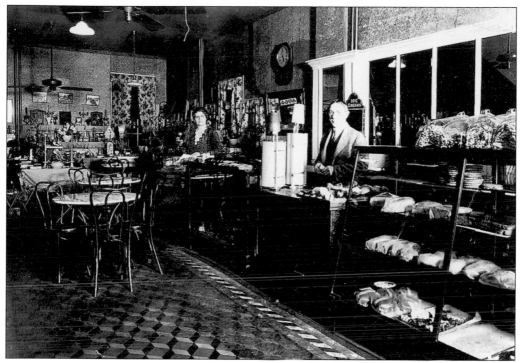

The West Ward of Downingtown was home to Barrett's Bakery, at 133 West Lancaster Avenue. In the photograph above, William and Elizabeth Barrett are ready for customers in their store; below, William stands in an empty bakery. The Barretts purchased the bakery in 1902 from S. Fondersmith, who started the Fondersmith bakery and ice-cream parlor in the 1870s.

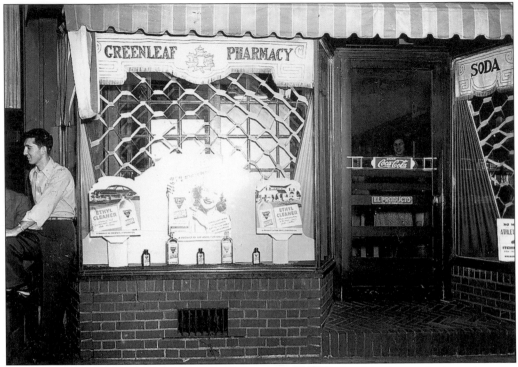

Greenleaf's Pharmacy, at 207 West Lancaster Avenue, was a favorite gathering place for youngsters in Downingtown. The pharmacy, shown in the top photograph in 1946, offered soda and snacks and even had pinball machines. A drugstore was first on the site in 1859. H. Raymond Greenleaf, known as "Greenie," was active in youth clubs and teams. The photograph below, taken in 1946, shows the Little Grill sandwich shop.

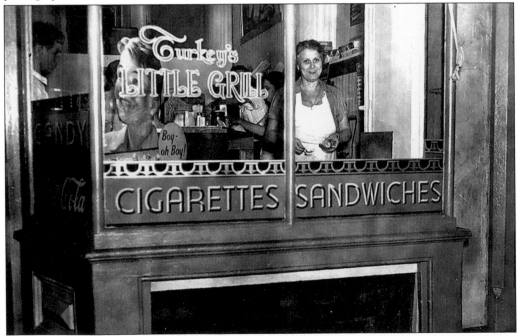

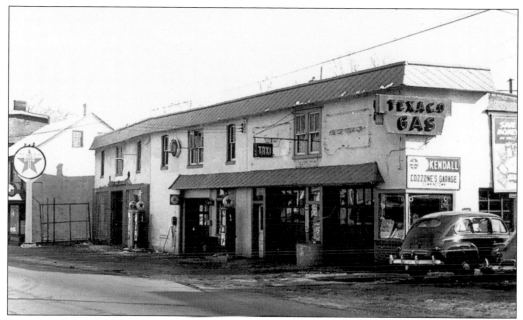

Downingtown also had several gas stations to provide necessary services for the vehicles traveling on the borough's roads. Shown above is Cozzone's Garage, which offered Texaco gasoline and also provided a taxi service. There was also a Cozzone Pontiac dealership in the borough. In the photograph below, some cars are parked in front of the Downingtown Women's Club. The volunteer organization was formed during the first half of the 20th century and was used to make supplies during World War II.

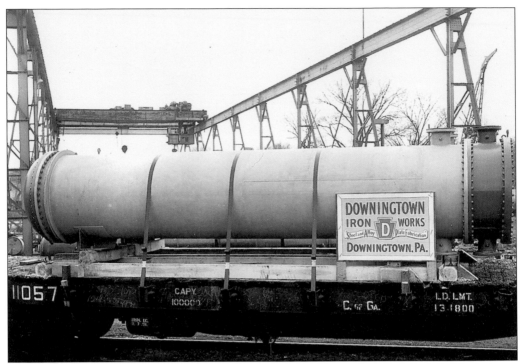

The Downingtown Iron Works was established in 1913, when three men—Park L. Plank, Louis C. Zimmerman, and Harold T. Abele—received a charter for the company. The building was located on the northeast corner of Pennsylvania and Wallace Avenues. The photograph above displays one of the pipes made at the ironworks; the photograph below displays other products made at the borough plant.

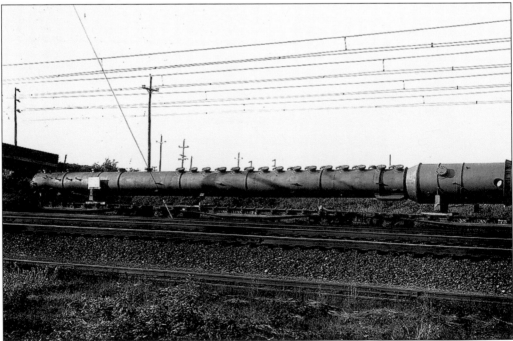

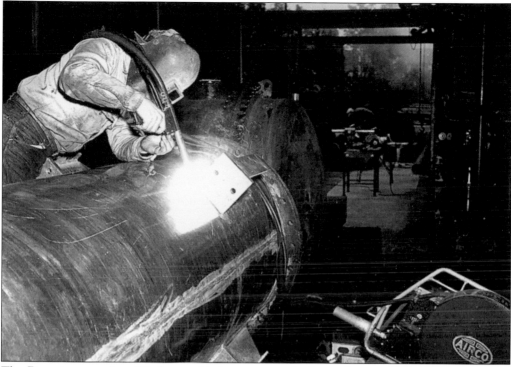

The Downingtown Iron Works provided numerous jobs for workers in the borough for almost a century. The plant has since been closed, and a drugstore has been built on the property. In the photograph above, a welder uses an "aircomatic" tool on the tube. In the background, another worker is tending to another project. The photograph below shows the working floor and various work stations of the company at Pennsylvania and Wallace Avenues.

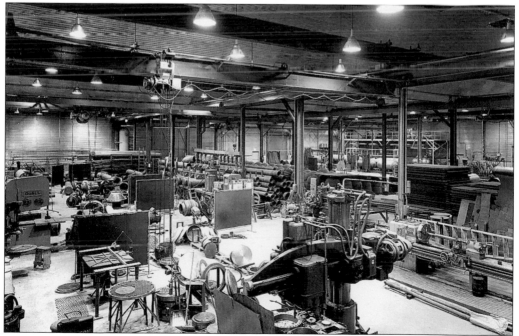

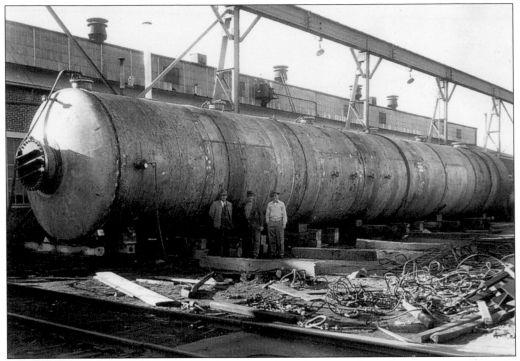

The Downingtown Iron Works worked on a number of large products for customers during its time in business. Above, three men stand in front of a tower that measures 12 by 95 feet. Below, a company carpenter known by all at the plant as "Brownie" stands by an oddly shaped product. One of his jobs was to secure tanks in cars before shipping.

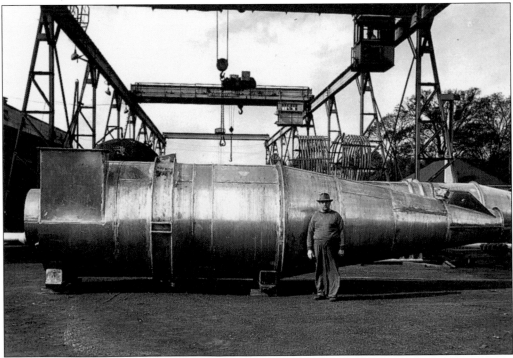

Many of the business leaders of Downingtown were also civic leaders. Shown to the right is Eber Garrett, an influential 19th-century entrepreneur, community leader, and Civil War veteran. Civic leaders connected with borough businesses continued throughout the village's history. In the photograph below is Downingtown National Bank president Richard Warren, who served for five years in the 1950s.

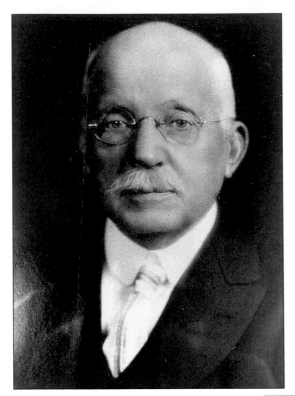

Thomas W. Downing, shown to the left, was not only president of Downingtown National Bank from 1919 until 1938, but he was also one of the founding members of the Downingtown Business Men's Club. The issue that sparked the formation of the club was the lack of proper passenger rail service to the borough. Below is another bank president, A. P. Reid.

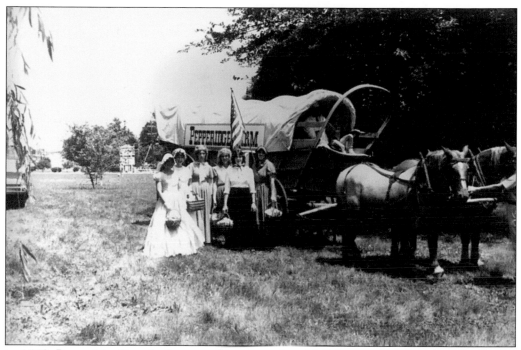

In 1949, Pepperidge Farm built a new factory on the old Cohansey Glass Works site off Boot Road on the southern side of Downingtown. At first, the company baked bread and then expanded to produce other products, including cookies, frozen puff pastry, rolls, and a number of other types of bread. The company was involved in the community and sponsored local sports teams. The photograph above includes a horse-drawn wagon for a community event, and in the bottom photograph, Rose Hardy (right) talks with an unidentified worker.

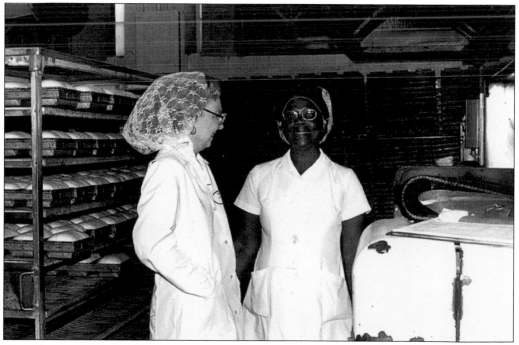

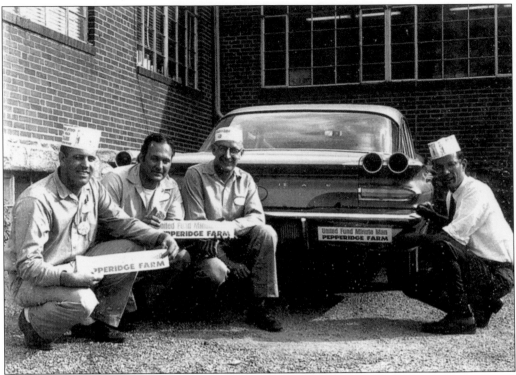

The four Pepperidge Farm workers are displaying bumper stickers and pins for Pepperidge Farm's "United Fund Minute Man." Below, two workers are taking a break near the biscuit maker. The Pepperidge Farm plant in Downingtown greatly expanded in the 1950s to make a number of new products, including the Delacre cookie made from a Belgian recipe.

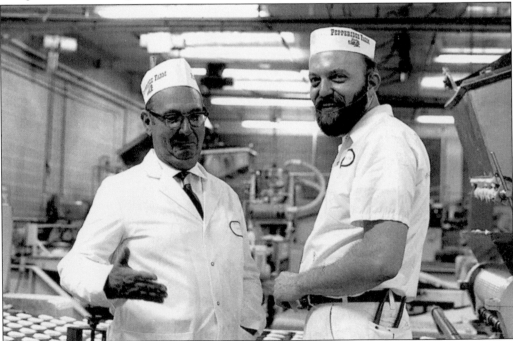

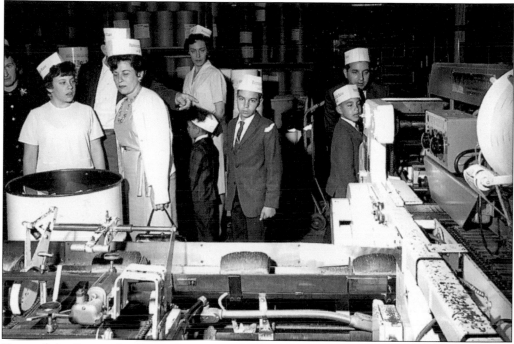

Tours of the Pepperidge Farm plant were popular among students at area schools. In the top photograph, young bakers wearing their Pepperidge Farm hats inspect the company's bread-making facility. Loaves are passing by students in the tray in front of the photograph. In the photograph below, workers are inspecting some of the plant's finished products under the watchful eyes of visitors. Rows of tray holders await goods in the background.

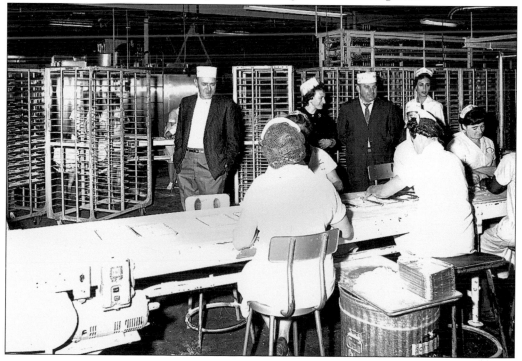

Joseph E. Miller, shown to the left, was more than a president of Downingtown National Bank. He was a photo-historian and put together a two-volume set of historic photographs of Downingtown. The next section of this book will highlight some of the Miller collection. In the photograph below are three trucks of the Chemical Leaman Tank Lines.

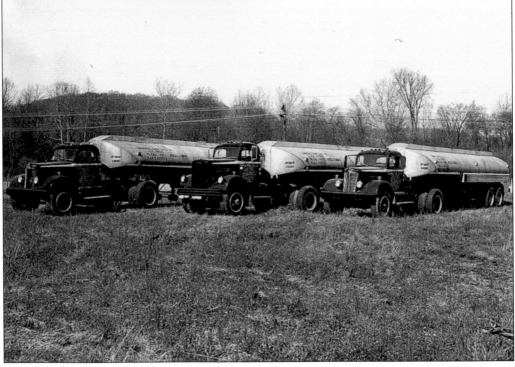

Six

THE MILLER COLLECTION

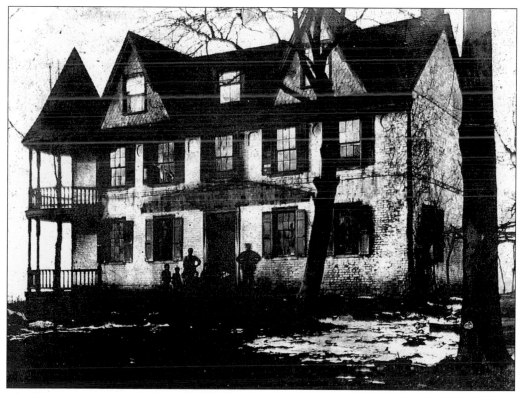

The Hunt mansion was built in 1727 and was located at the corner of West Lancaster Avenue and Hunt Avenue in the western section of Downingtown. It was built in the old English style, and the estate of Roger Hunt was 500 acres, including the mansion. He had five sons and two daughters, and all were born in the mansion. The information in this chapter comes from the work of Joseph E. Miller.

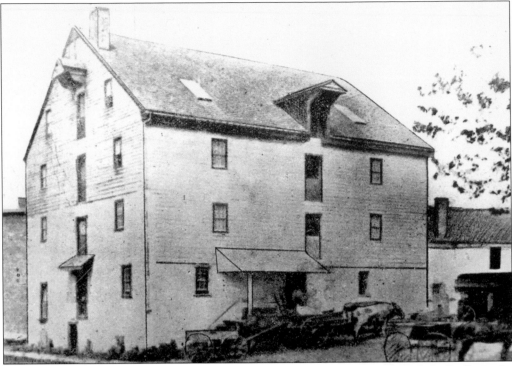

The top photograph shows the Shelmire Grist Mill, built in 1716. The Bicking Paper Company purchased this mill in 1881. The small building next to the mill is the old Shelmire railroad station. The photograph below shows a gristmill built *c.* 1739. It was located on Race Street. The first owner was Roger Hunt, and it was later sold to the Ringwalts.

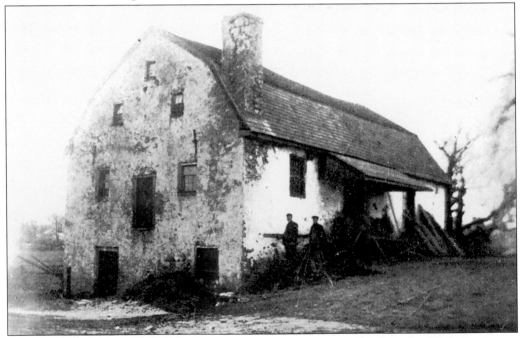

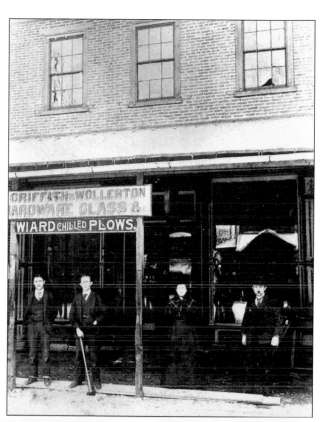

The Griffith and Wollerton hardware store is seen to the right. From left to right are Charles W. Reel, Llwelyn B. Lewis, Ole M. Griffith, and Theodore W. Griffith. According to the sign, the store sold everything from glass to Ward plows. The people shown below are, from left to right, unidentified, Lewis Roberts, Hugh Gormley, E. P. Fisher, John B. Wollerton, and Theodore M. Griffith.

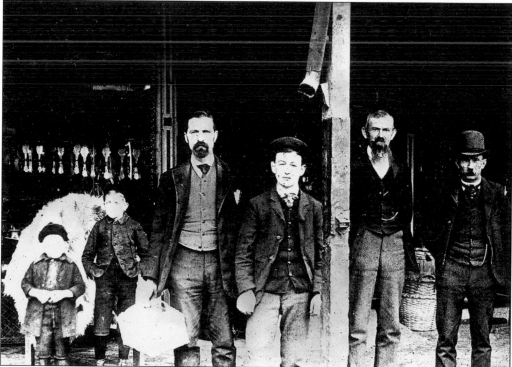

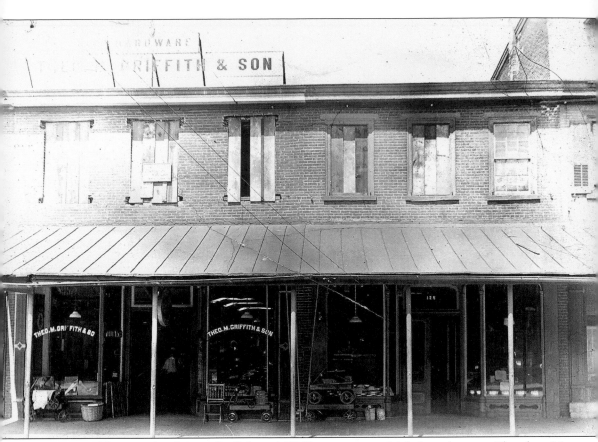

Pictured here is the former Griffith and Wollerton store, which later became Theodore M. Griffith and Son. All of the building was not the hardware store, as the far-right office belonged to William B. Stauffer, a tinsmith. In 1922, Ole M. Griffith and Edgar I. Griffith purchased the Stauffer store and made one large store. The building then became Theodore M. Griffith and Son. Seen on the porch are small wagons ready to be sold. In 1926, Edgar I. Griffith was one of the charter members of the new Rotary Club in Downingtown. The service club established a Downingtown Rotary Foundation, and the foundation went on to give financial aid to a number of worthy borough students wishing to advance their education.

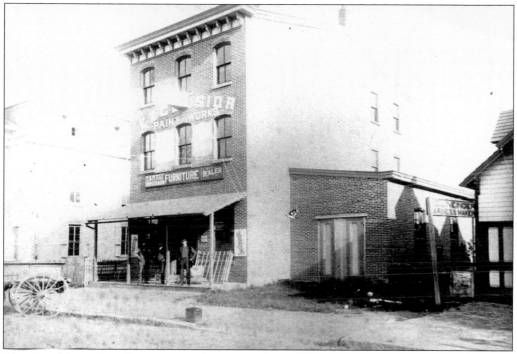

The Excelsior Paint Store, seen above, stood on West Lancaster Avenue near the old Downingtown High School. Joseph H. Johnson and his brother owned the building. The first floor was occupied by Thomas M. Perdue, an undertaker. The paint was made on the second floor. The men in the photograph are Frank Mercer (left), E. C. Lineinger (center), and Thomas M. Perdue. The small building was the E. C. Lineinger shop. The Frank McCaughey home, at 114 West Lancaster Avenue, is shown below. McCaughey owned a general store.

The photograph above shows John E. Parke's former home, later owned by S. Austin Bicking. The building was torn down, and a gas station took its place. Notice the large number of people on the porch. The photograph below shows the horse Prince, owned by Penrose Moore. Moore had a reputation of always having fine horses and wagons. The photograph was taken at the rear of the S. Austin Bicking home.

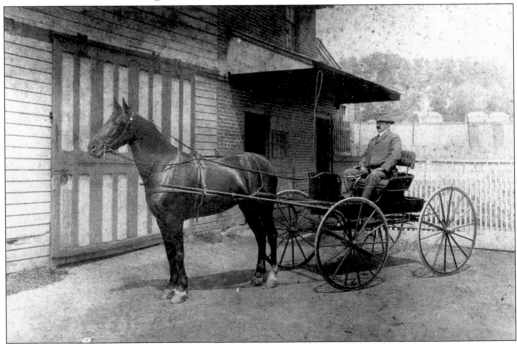

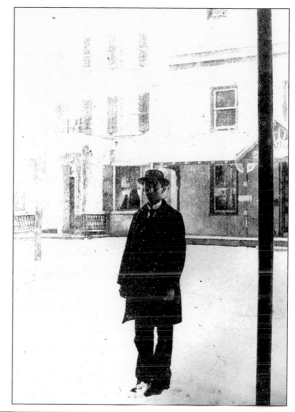

Edward Deputy, a barber, is seen standing in front of the Grange National Bank. The building to the left in the image was the home of Joseph Freck, father-in-law of Hall of Fame pitcher Herb Pennock. The photograph below shows 126 and 128 East Lancaster Avenue, which are the Ellis Miller dwellings. Sitting on the porch to the left are Mrs. William C. King and Annie Emery, Miller's daughters. The homes are decorated for the borough's 50th anniversary in 1909.

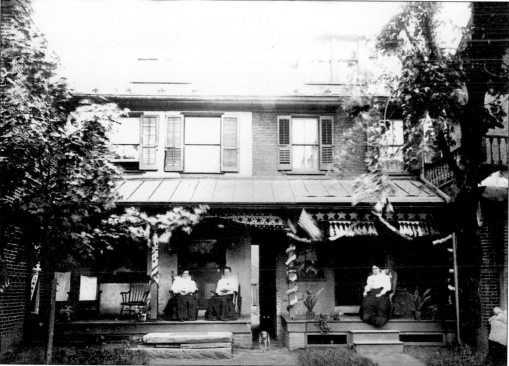

The stores on this page are located on Lancaster Avenue in Downingtown. Seen to the left in the upper photograph is a tailor shop used by Edward Ray at 127 East Lancaster Avenue. Later, a shoe store was on the premises. In the same photograph to the right is a ladies' store operated by Mrs. William G. Kurtz. Below is the Bareford Brothers store, at 135 East Lancaster Avenue. Shown are, from left to right, Ed Hartman, John Bareford, Jennie Darlington, and Mark Bareford. Sitting in the chair is Mary Smedley. The two girls on the steps are Eva Bond (left) and Elizabeth Darlington.

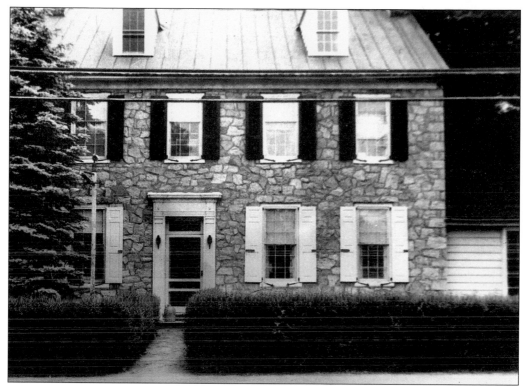

The building known as the Jug House is shown above. Located at 726 East Lancaster Avenue, it is the first house west of the Friends meetinghouse. The name comes from the stone cut in the shape of a jug and built into the structure on the second floor (near the window on the left). To the right is a closer view of the stone.

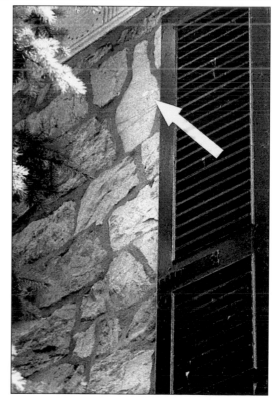

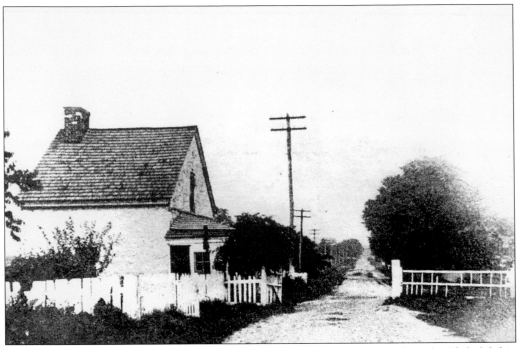

Two tollgate houses are shown on this page. Above is the tollgate located on the Philadelphia and Lancaster Pike, just east of the borough on a stretch of road called Lincoln Highway. A nut tree grove owned by John Hershey occupied the land. It is also opposite the Jug House. The photograph below shows the tollgate on the Horse Shoe Pike, Route 322, on the curve of the farm once owned by Joseph H. Baugh.

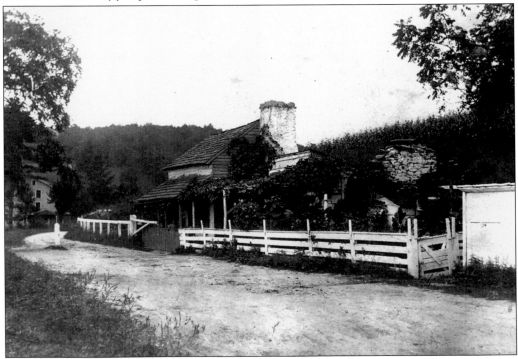

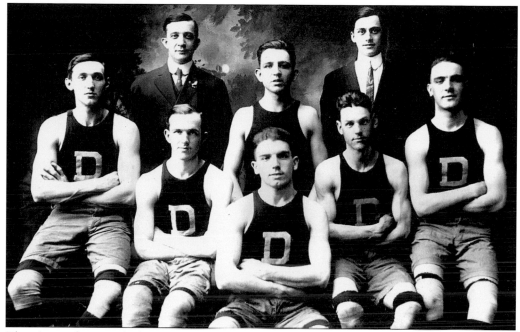

The above photograph shows the Downingtown All-Scholastic basketball team that won the championship of eastern Pennsylvania in 1912–1913. From left to right are the following: (front row) Herb Steen, Joseph E. Miller, Wayne Moore, Jack Stine, and George H. Gensemer; (back row) Robert T. Ash (manager), Frank Breuninger, and Howard D. Baldwin (treasurer). Shown below is the Downingtown Athletic Association baseball team of c. 1902. From left to right are the following: (front row) Albert Garner, Charles Newlin, and Laban Stroud; (middle row) James Fitrer, Edgar Hutchison, Robert T. Ash, James Barton, John Lilley, and Jukey Ford; (back row) Frank Duff, Robert McCaughey, Albert Karns, Kirk Smith and Robert Ash Sr. (manager).

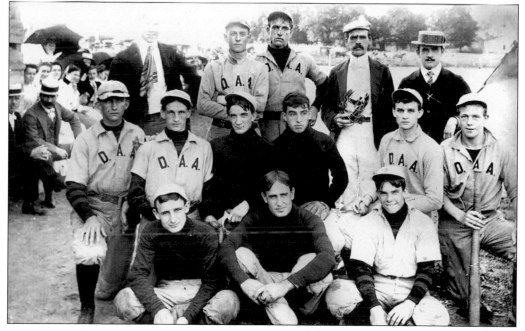

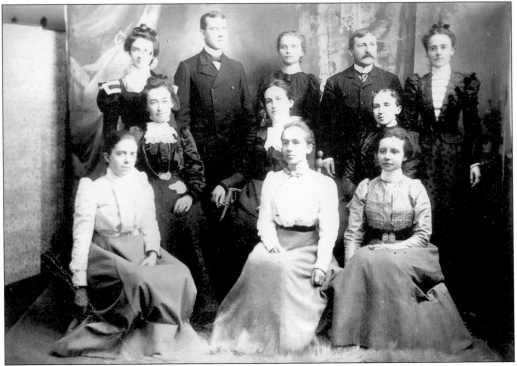

Above are some of the teachers in Downingtown schools in 1890. The salary for women teachers was $24 per month. From left to right are the following: (front row) Sara Liggett, Ella F. Smith, and Eva Moore Shillady; (middle row) Hanna Bicking, Clara Ludwick McConnell, and Mary Speakman; (back row) Mabel Wilson Witmar, Ernest Sipper, Louise Huber, Prof. John R. Hunsicker, and Cordilla Walker Fisher. The photograph below shows the old Downingtown High School on West Lancaster Avenue. The building was torn down in 1909.

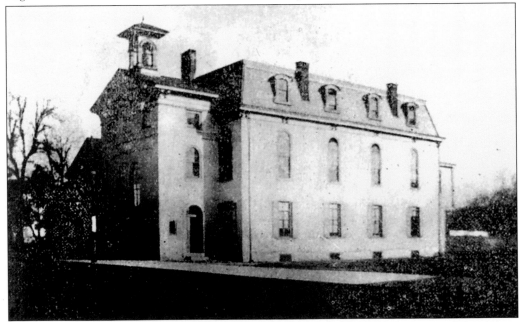

The photograph to the right shows one of the trendsetters of Downingtown. T. Vance Miller reportedly owned the first high-wheel bicycle in the borough. Notice the painted backdrop with a country scene behind Miller and his bicycle. The bottom photograph is of a picnic of the Washington Camp 338 of the Patriotic Order of the Sons of America. The organization held a picnic each year, and it was always held at Fetters Grove or Hickory Park.

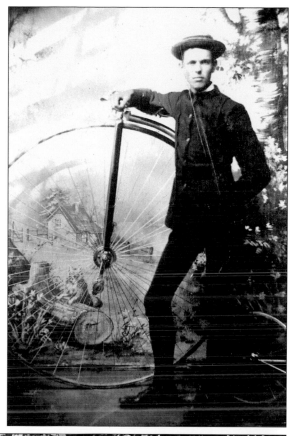

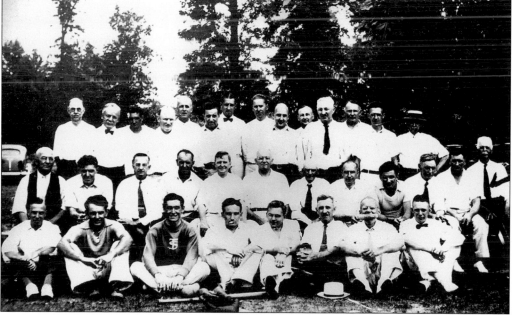

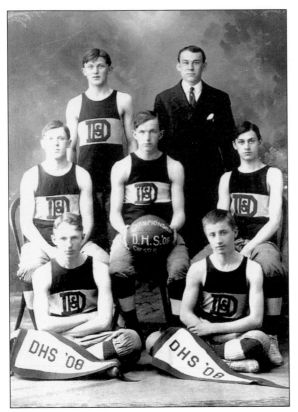

The first Downingtown High School basketball team was organized in 1907, and the team won the Chester County championship a year later during the 1908–1909 season. The championship team, seen to the left, includes the following: (front row) Frank Mancill and Paul Lowry; (middle row) Warren Dolbay, Joseph E. Miller, and Howard D. Baldwin; (back row) William Good and Roy Connell. Below is the Downingtown Bicycle Club. The photograph was taken in Fairmount Park, Philadelphia, in 1900. On Sundays, the cyclists would start in front of the Swan Hotel in the borough and bicycle to various locations.

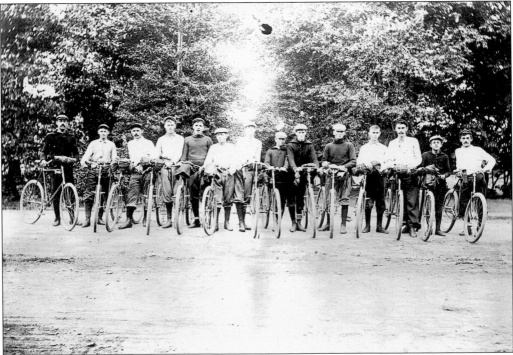

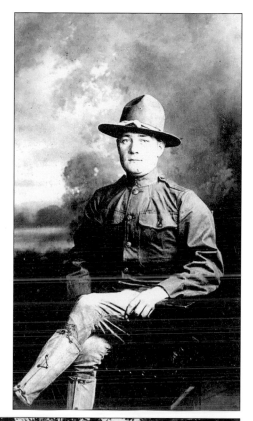

Charles F. Moran, seen to the right, was the first Downingtown soldier killed in World War I. Moran, a resident of 119 Brandywine Avenue, died on July 18, 1918, in the battle of Chateau-Thierry with the 9th Regiment Infantry. He was decorated for his bravery. In the photograph below are members of the Charles F. Moran Post No. 475 of the American Legion, named for the Downingtown soldier.

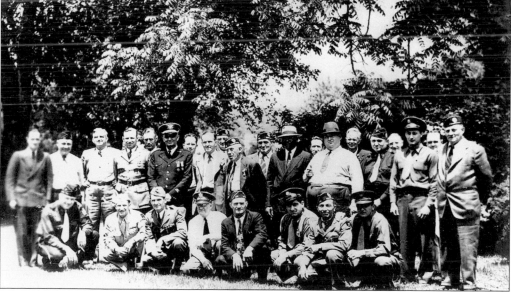

In the early days of Downingtown, the public library was housed in various stores. The first public library was in the Jacob Edge store, where the Downingtown National Bank now stands. The building seen above was constructed *c.* 1856, and Carl Hines operated a school for boys in the building. Below is the current library, used by Mary B. Thomas and her sisters as a boarding school for girls beginning in 1839.

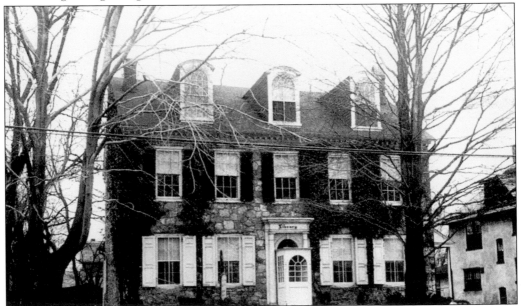

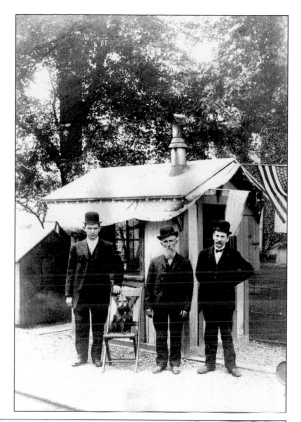

The three men to the right are Frank Zittle (left), Harrison Dewey Hedricks (center), and Daniel Zittle. Hedricks was the railroad watchman at the crossing on Lincoln Highway, between Chester Glisson's business and the Bicking paper mill. Below is the Minquas firehouse, and the gates that Hedricks operated can be seen. The fire company was organized on May 4, 1905.

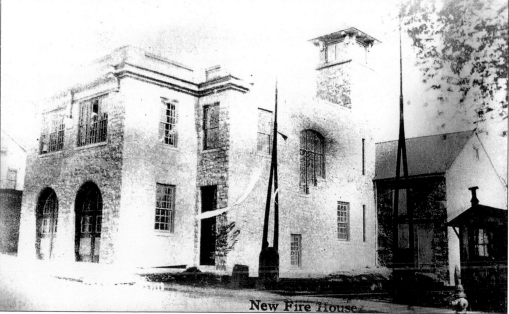

New Fire House

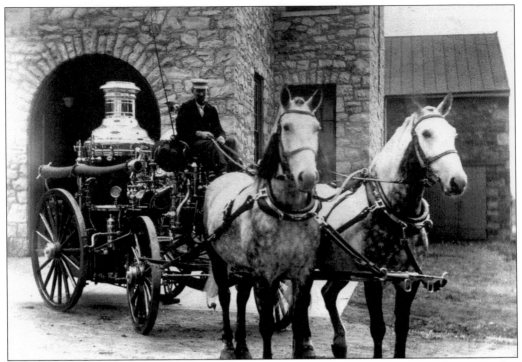

The above photograph shows Minquas Fire Company No. 2 of Downingtown and its steam fire engine and two horses. The driver of the engine is William Laird. The horses are Joe, named after Joseph A. Bicking, and Penn, named after Penrose Moore. The photograph below shows the two borough fire stations—Alert Fire Company No. 1 (left) and Minquas Fire Company No. 2 (right).

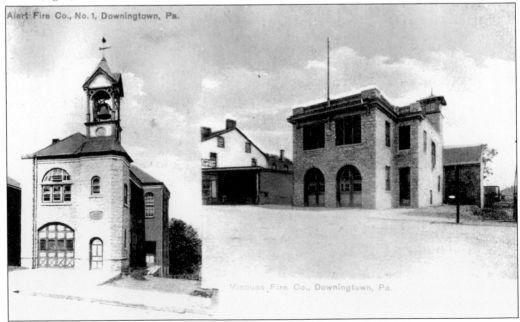

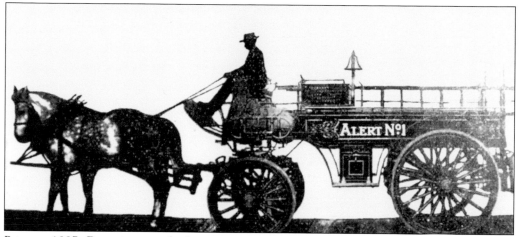

Prior to 1887, Downingtown had no organization or apparatus for fighting fires. On August 18, 1887, a group of men met to organize a fire company, and Alert Fire Company No. 1 was formed. They purchased a steam fire engine that was mostly pulled by hand, and in 1905, two horses were purchased. Seen below are horses Gib, named after Louis L. Gibney, and Ped, named after Thomas Pedrick. The driver is Winfield Downey.

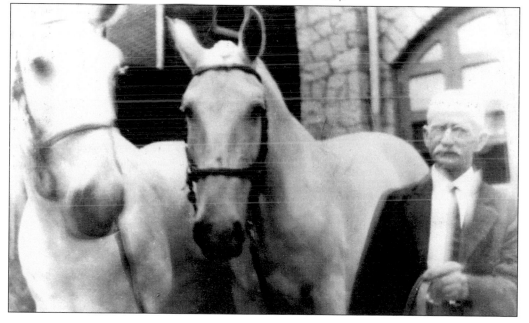

To the left, Harry Bender (left), Harry Harvey (center), and Palmer Keech are sitting in front of the office of the old Frank P. Miller Paper Company. The business is shown in the bottom photograph. The company started in business in March 1881 to manufacture paper for bookbinders. It was previously known as Solitude Mill and became the Downingtown Paper Company. During its early days, the business turned out a ton of products per day.

Two survivors of the Spanish-American War took part in a Memorial Day event in the borough in 1957. To the right is Horace S. Carpenter, and below is Robert Walker. Both were Downingtown residents. Carpenter died within a year of this photograph being taken, leaving Walker as Downingtown's last surviving Spanish-American War veteran.

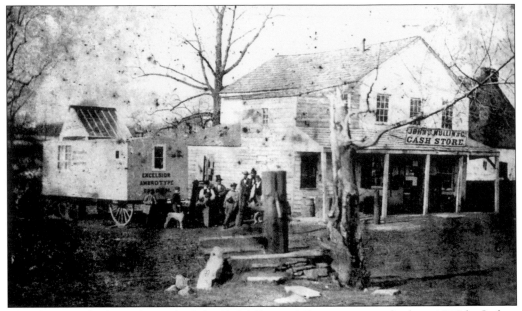

The photograph above shows the John B. Mullin and Company store, built in 1818 by Joshua Hunt. The photograph was taken in 1860 after the store was closed. The lot was then used for a sawmill. It was on the corner of Lincoln Highway and Brandywine Avenue where the Downingtown National Bank now stands. The photograph below shows the H. B. Sides drugstore, on Lancaster Avenue. The man with his hat on is H. B. Sides. The building on the right is the Masonic Building. The barbershop belonged to Philip Broachard. On the left is a cigar store.

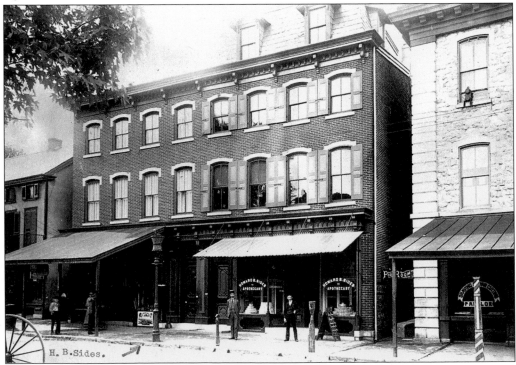

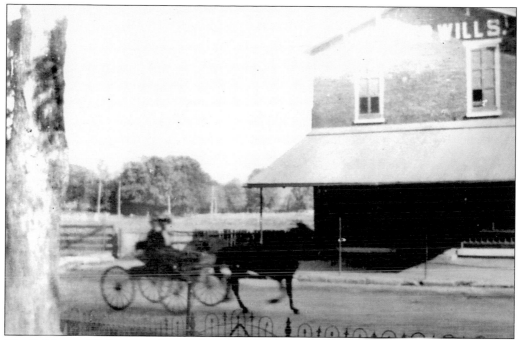

The J. Hunter Wills store, shown above, was built in 1872 in the east end of Downingtown where the East Ward School now stands. The store was well stocked with groceries and notions. The postcard below shows the famous Downingtown Tea House, located at 341 East Lancaster Avenue. Thomas Downing built it in 1729. The Silvis sisters ran a teahouse and gained a reputation for their delicious food, especially their chicken and waffles dish. The business was the subject of an article in a national magazine.

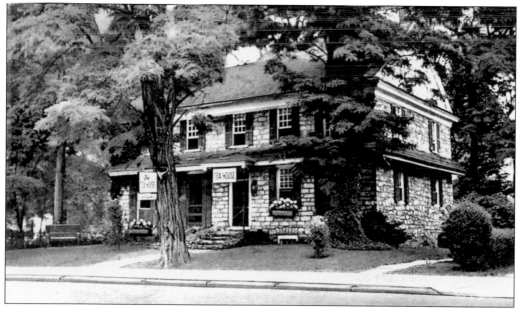

The photograph to the left shows the old Archive Printing Office, at 147 East Lancaster Avenue. The building was later used as a shoe-repair shop. Daniel H. Zittle's cigar store and painting and paperhanging business were next to Archive Printing. Those in the photograph are Daniel H. Zittle (left), Frank Zittle (center), and Ida Zittle. The girls are Daniel Zittle's daughters, Myrtle, Pearl, and Hettie. The bottom photograph shows East Lancaster Avenue in Downingtown. The scene includes Harry Worrall's drugstore.

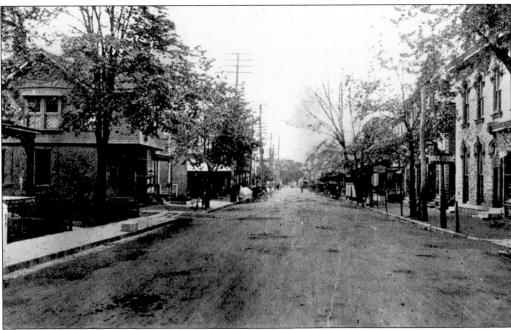

The old Miller Brothers clothing store, seen to the right, was located at 111 East Lancaster Avenue. The Miller brothers built the store and were in business for 57 years. Those in the photograph are Joseph E. Miller, T. Vance Miller, Horace V. Miller, ? Weeder, Leon T. Miller, Ellis M. King, William Walton, and Joseph T. Miller. The photograph below shows Clarence Miller's barbershop, which was to the left of the Miller Brothers store. The building was at one point the Charles News Stand on Lancaster Avenue.

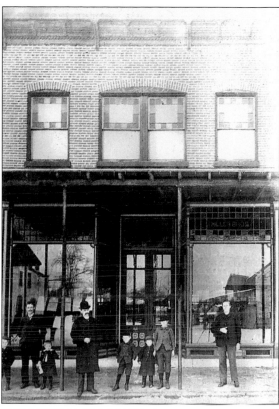

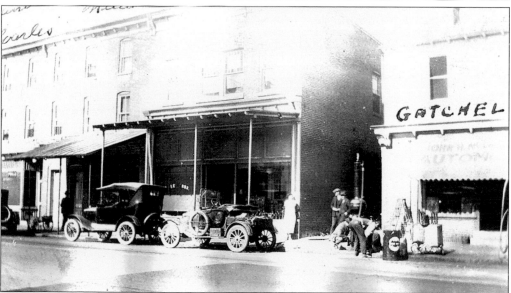

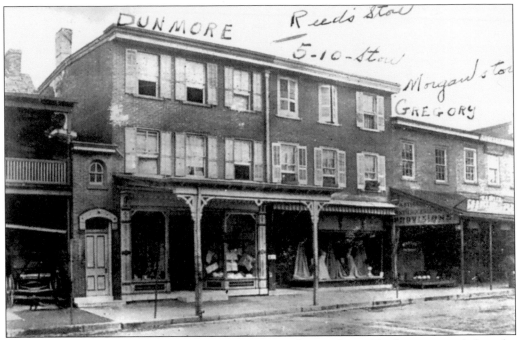

J. Harry Reed's store, on East Lancaster Avenue, is shown above. To the extreme left is the site occupied by the farmer's bazaar and, later, by Ritchie Motors. The next store to occupy that location was the Dunmore Sporting Store. A five-and-dime store replaced that business, followed by a grocery store operated by William Morgan. The photograph below shows the Morgan store. Shown are Joe Peoples (in the doorway), Flora Morgan, and T. Benton Dowlin (far right). The man behind Dowlin is John Wollerton, a partner in a hardware store.

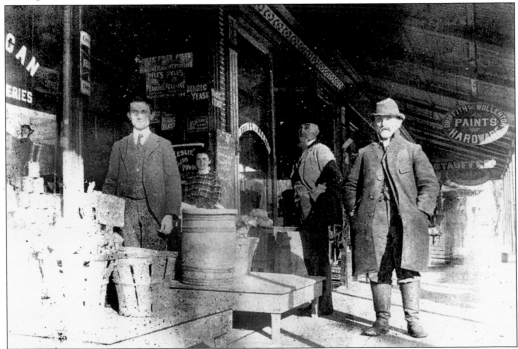

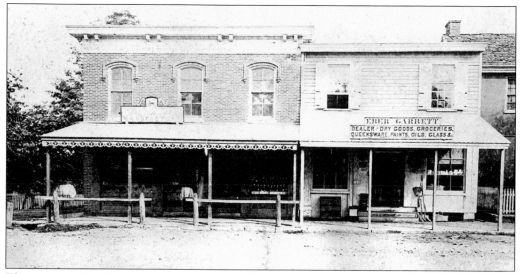

The stores in the above photograph stood at 101, 103, and 105 East Lancaster Avenue, directly across from the Swan Hotel. The first store is Richard Webster's harness-making business; the second, the William Kurtz shoe store; the third, the Eber Garrett grocery store. The building set back from the road is a boardinghouse operated by a Mrs. McClure. That site was later occupied by the Charles News Stand. To the extreme left is the Billy Hess restaurant. The photograph below shows East Lancaster Avenue, with horses and buggies lining the street.

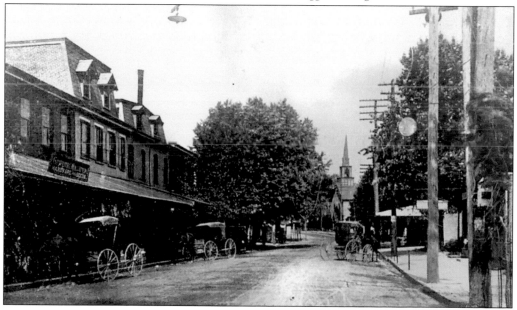

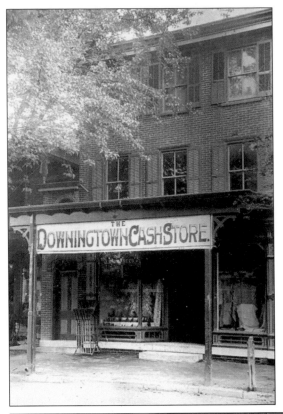

The building used for the Downingtown Cash Store, shown to the left, became a sporting-goods store in the 20th century. Below is a delivery wagon of the Anton Hertel bakery, located in east Downingtown. Hertel, who moved to the borough after living in Philadelphia, operated a bakery and ice-cream store in the building once occupied by a taproom.

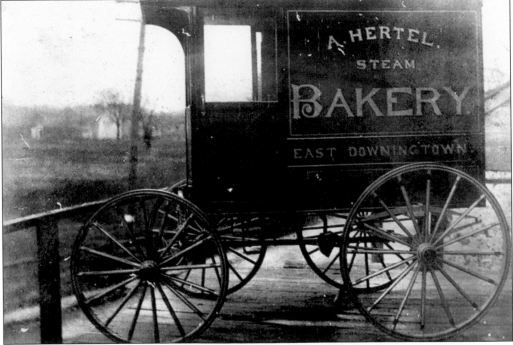

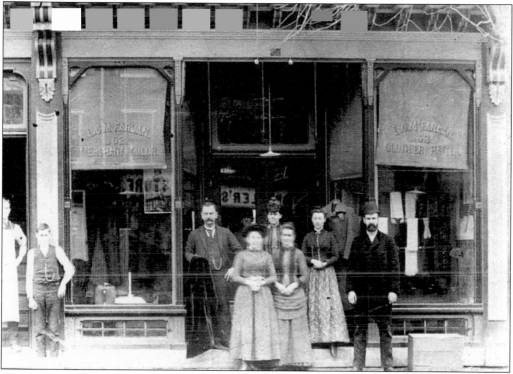

The L. C. McFarlan store, shown above, was located at 116 East Lancaster Avenue. It later became Hutchison's Pharmacy. L. C. McFarlan is the man with a piece of cloth in his hand. To his left stands Mrs. T. Vance Miller and Laura Ralston. The two women in front are Ida Berstler and Mary Foy. The man is unidentified. The building was constructed in 1879. The photograph below shows East Lancaster Avenue, and the arrow in the photograph is pointing to one of the old gas lamps that gave light on borough streets.

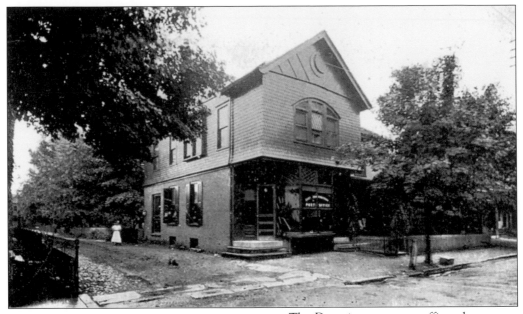

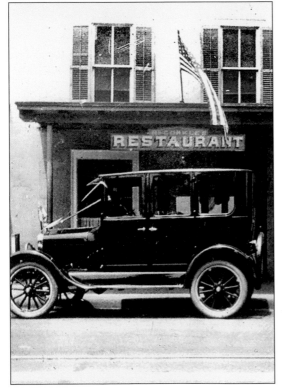

The Downingtown post office, shown above, used to be located on Lancaster Avenue in a building that later became the Colonial Bake Shop. At one point, the borough had two post offices. Few, if any, towns the size of Downingtown had two post offices. The photograph to the left shows the famous oyster house of Hattie McCorkle. The car in front of the restaurant belonged to Lindsay McCorkle.

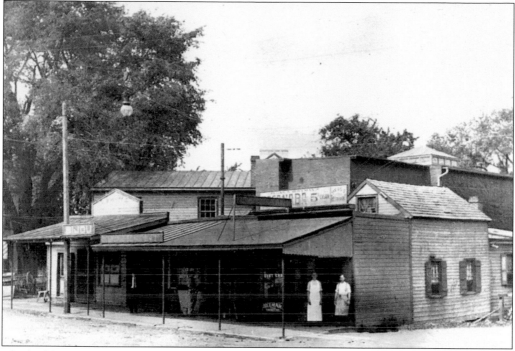

The building shown above belonged to Isaac E. Roberts. It stood in the center of Downingtown. For many years, the Billy Hess oyster house, famous for its stews, was located in the building. The man to the right in the photograph is Billy Hess. The business to the left of the restaurant was a grocery store operated by William H. Roberts. The photograph below shows the Wesley Jones blacksmith shop, located on Park Lane. The road in front of the shop used to be part of the Lancaster Pike before the bridge was built over the Brandywine River.

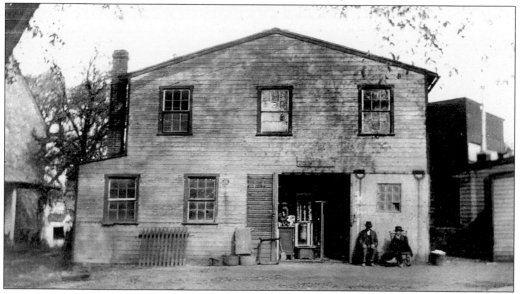

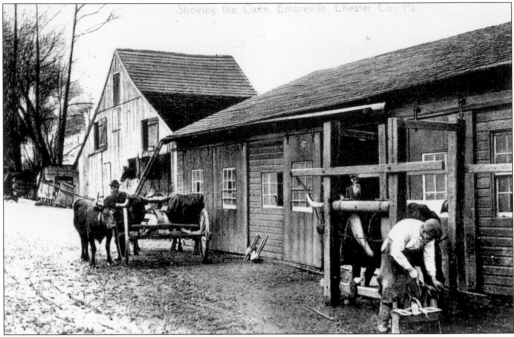

Horses were not the only animals to receive new shoes in the Downingtown blacksmith shop shown above. The workers are shoeing an ox. Since oxen have short legs, they are put into a stock that lifts them off the ground so the blacksmiths can work on them. In the photograph below, according to Joseph Miller, a cat joins the picket line at the Bicking Paper Company. The cat has a card around his neck.

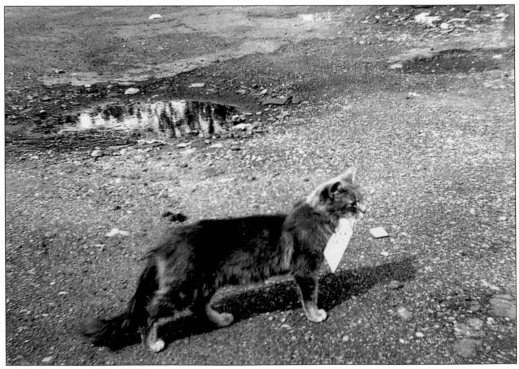

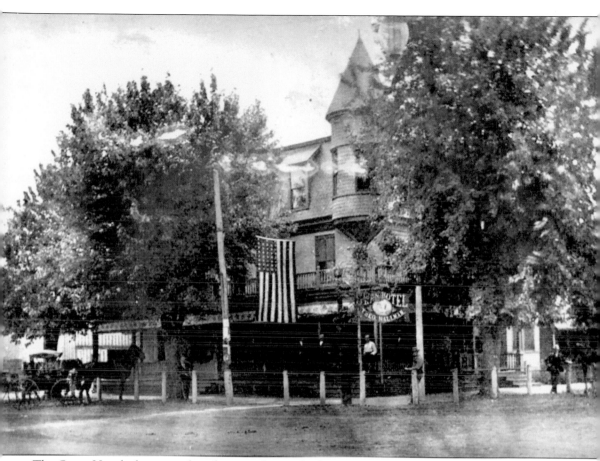

The Swan Hotel, shown in this photograph, was built c. 1804. The hotel was the place where the borough of Downingtown was incorporated on May 12, 1859. An election was held at the hotel on May 28, 1859, and Capt. James Lockhart was chosen the borough's first burgess. Lockhart received 58 votes to Charles Downing's 29 votes. The Swan had a reputation of being a very fine and well-kept hotel, noted for its hospitality and good food. It was said that "no traveler will make a mistake when he puts his name on the hotel register and asks when dinner will be served." Some of the proprietors of the Swan Hotel were Parke, Evens, Diller, Millerson, Ringwalt, Tucker, Sheeler, Hawkins, Theodore Hallman, David Martin Barry, and Rittenhouse. On April 28, 1814, a boundary line was instituted between Philadelphia and Downingtown, with the sign of the Swan serving as the western terminating point. The man standing on the steps in this photograph is Theodore Hallman, a proprietor of the hotel.

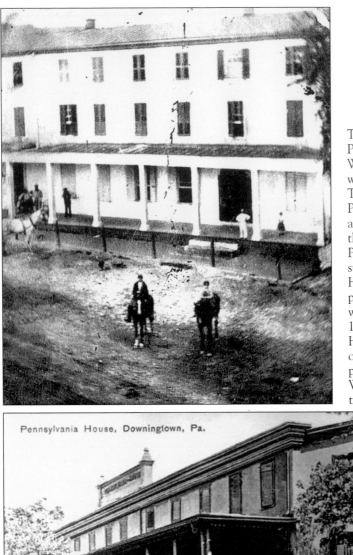

The deed for the Pennsylvania House, at 212 West Lancaster Avenue, was dated January 2, 1832. The site was across from the Pennsylvania Railroad station, and at one point, most of the passenger trains between Philadelphia and Pittsburgh stopped at the Pennsylvania House for meals. The first proprietor was Peter Osborne, who took that position in 1835. The Pennsylvania House had a number of owners over the years. The photograph below shows Wilmer E. Biles with the hack that he operated.

Pennsylvania House, Downingtown, Pa.

The three houses next to the Presbyterian church were known as the Halfway House and are shown in this photograph. They were so named because they were halfway between Philadelphia and Lancaster. John Edge obtained a tavern license for the Halfway House in 1790. After the defeat of George Washington's army at Brandywine on September 11, 1777, the Continental Congress evacuated Philadelphia and fled to York, Pennsylvania. Some members are reported to have stopped at the Halfway House. Also, a biographer of Pres. James Buchanan said that Buchanan had just finished a meal at the Halfway House when he found out about the death of his sweetheart. Downingtown had three important taverns in the borough in the 1800s, and they were the Ship, the King in Arms, and the Halfway House.

The home of Joseph Huggins Jr. was located at the corner of East Lancaster Avenue and Uwchlan Avenue. At different times, the building has housed the Downing Hotel, the King in Arms, and the Washington Inn. John Downing was the first tavern keeper (in 1761), and he was followed by Richard Cheyney, who was the keeper until the outbreak of the American Revolution. Hunt Downing was the keeper at the time of the Whiskey Insurrection and was also quartermaster to some of the troops near the tavern. The hotel was a noted stopping place for dignitaries, including presidents, governors, Supreme Court judges, and other officials. The building also served as a post office. Pook and Pook antiques now occupies the building.

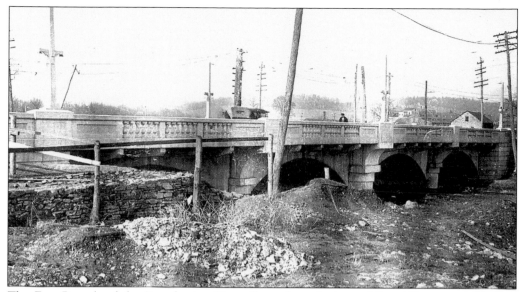

The East Branch of the Brandywine River flows through the middle of Downingtown as it makes its way through Chester County and into Delaware and empties into the Christina River in Wilmington. Spanning the river in the above photograph is the Lancaster Avenue Pike Bridge, built in 1802. The same bridge is shown below with the trolley bridge. A new bridge now spans the Brandywine near the borough hall.

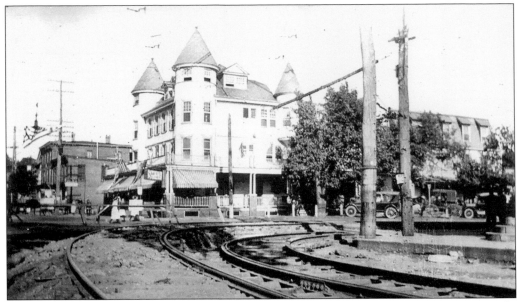

An important Chester County public transportation system, a trolley line, ran from Coatesville through Downingtown and on to West Chester. The photograph above shows the laying of the track through the center of the borough. In the background is the Swan Hotel. The photograph below shows a trolley car as it crosses the bridge spanning the Brandywine River. The first trolley car came into Downingtown from West Chester in 1902.

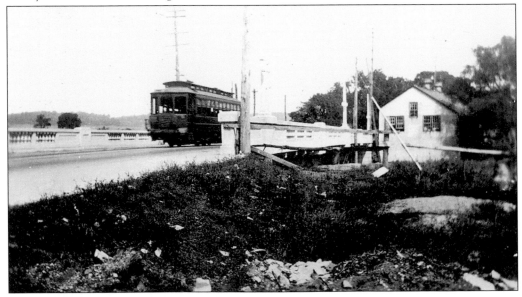

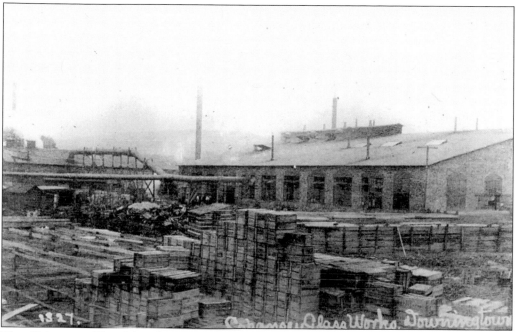

The Cohansey Glass Manufacturing Company, shown above, came to Downingtown from Bridgeton, New Jersey, in 1900. The company employed about 600 people and offered laborers a wage of 40¢ per day. The Pepperidge Farm plant was built on the glass company land later in the 20th century. The photograph below shows part of a train operated by the Philadelphia and Reading Railroad. It was called the Chester Valley Railroad. Engineer James Moran is shown standing beside the engine.

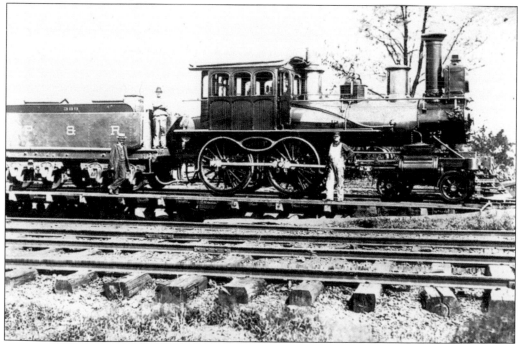

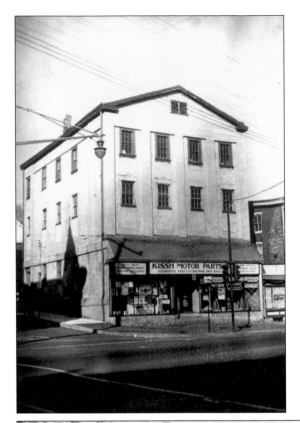

Banking has been a big business in Downingtown. The first borough bank was organized under the banking laws of Pennsylvania on September 3, 1860, and operated from the first floor of the Odd Fellows hall. The building became Kissh Motor Parts in the 20th century, as shown to the left. The bank went into operation on May 16, 1861, and on April 1, 1862, the business moved to East Lancaster Avenue across from St. James Episcopal Church, as shown below. The bank became a national bank on December 30, 1864, and moved to its current location at the corner of East Lancaster and Brandywine Avenues.

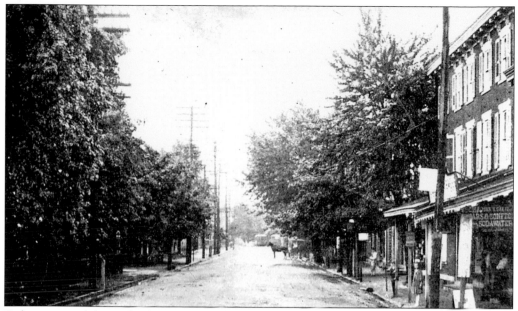

Before automobiles and other vehicles filled Downingtown's streets, the roads were lined with trees, and horse-drawn buggies dotted the byways. The photograph above shows East Lancaster Avenue in a view looking west from the railroad track to the center of town. Below is the Josiah Swank Coal, Wood & Ice Company, located on Washington Avenue across from the old Beloit Company. Swank was a prominent businessman and one of the last surviving members of the Hancock Post No. 255 of the Grand Army of the Republic.

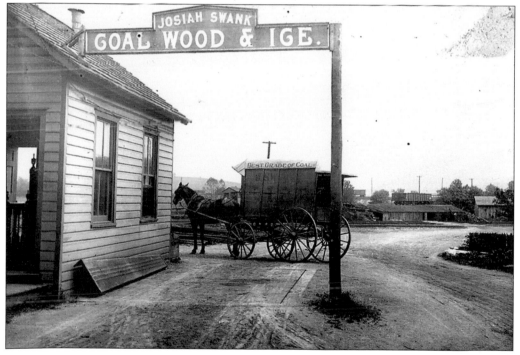

The Miller Brothers store, shown to the left, stood at 111 East Lancaster Avenue. It later became a jewelry store. The two boys sitting on the steps are Joseph E. Miller (left) and Leon T. Miller. Seen below is the George T. Jones and Son carriage factory and blacksmith shop. The business was located at the corner of East Lancaster Avenue and Park Lane. The man standing by the wheels is Wesley Jones, the blacksmith. The man with his hat in his hand is carriage builder George T. Jones. The man sitting with his hands in his pockets is Jesse Pollock.

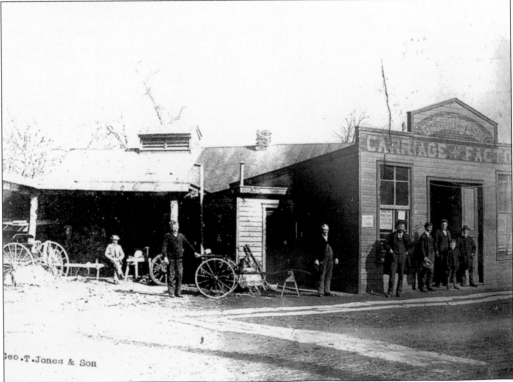

Seven

FIREFIGHTERS

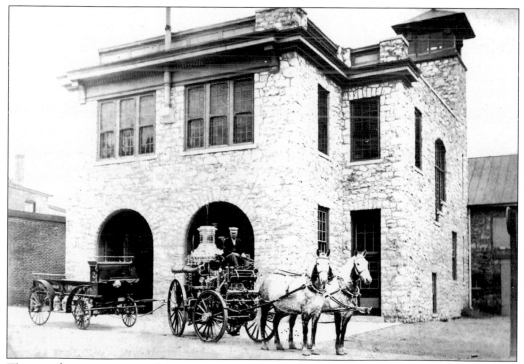

The two fire companies in Downingtown—Minquas and Alert—have played a central part in the lives of many borough residents in the past century. Alert Fire Company No. 1, formed in 1887, is the oldest fire company in Downingtown. Minquas Fire Company No. 2 was formed after the Alert building on Downing Avenue became too crowded; also, many members felt the Alert building was too far east in the borough to serve the developing manufacturing community in the borough. Shown here is the Minquas building.

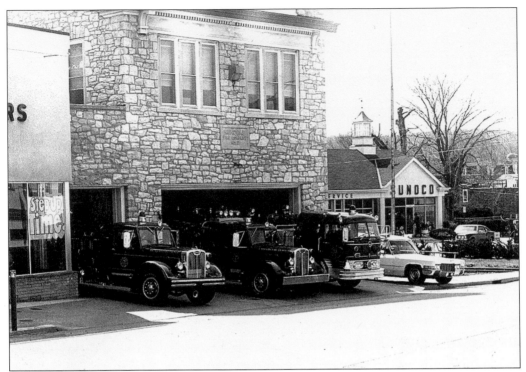

The above photograph shows the Minquas Fire Company's building on Lancaster Avenue and two pumpers, a squad truck, and a Cadillac ambulance. Shown below are some older pieces of equipment in a field in Downingtown.

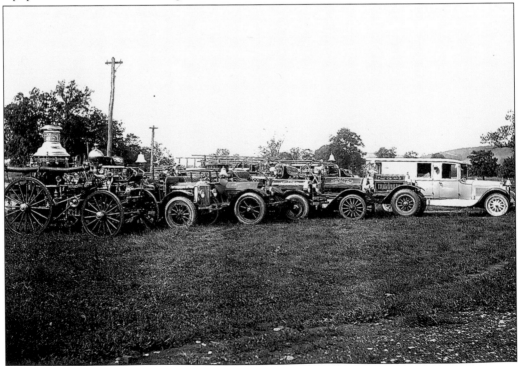

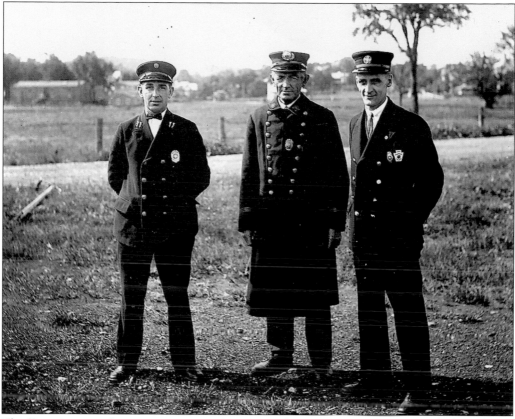

The Downingtown fire companies are volunteer outfits, and many community leaders served in some capacity in one of the units. Shown above are three officers of Alert Fire Company No. 1. They are John Bray (left), John Corcoran (center), and Martin Binder. Corcoran also served on the town's police force. Below, Downingtown firemen pose for a picture.

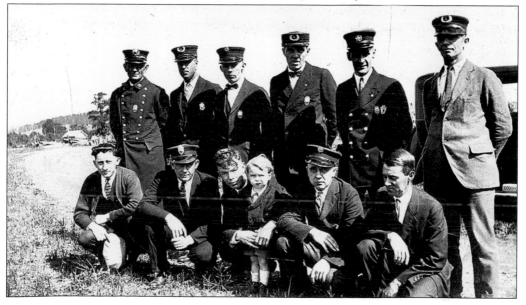

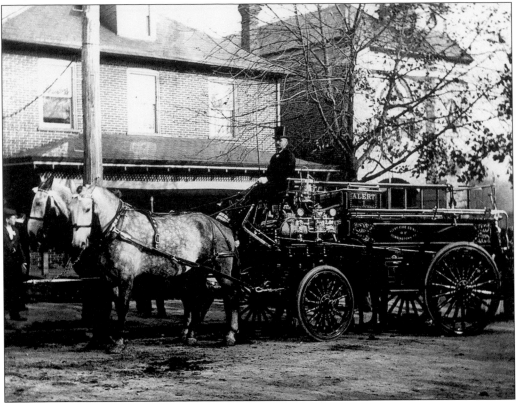

The equipment used to fight fires changed in Downingtown along with the times. Also, the volunteer firefighters have kept up with advanced training techniques over the years. Above, horses Gib and Ped are shown ready to take one of the Alert Fire Company's trucks into action. The photograph below shows new versions of fire trucks, ones without horses.

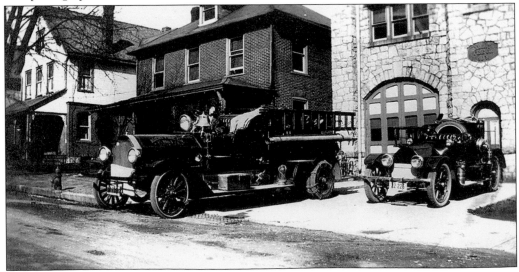

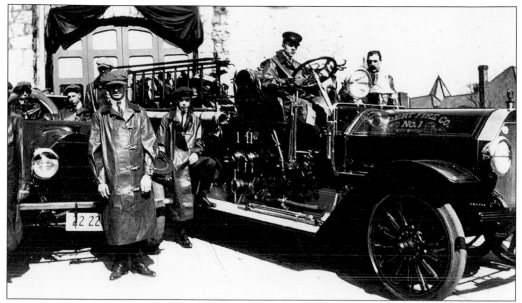

Firemen spend a lot of time making sure fire trucks and other pieces of apparatus are in excellent working order and that they are ready for parades. Members of Alert Fire Company No. 1, as shown in these images, also take pride in their own appearance. Members of both Alert and Minquas have participated in a number of parades in Downingtown and throughout the region.

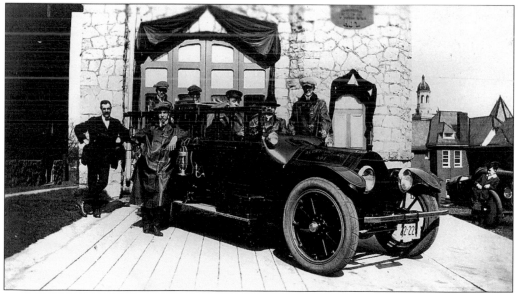

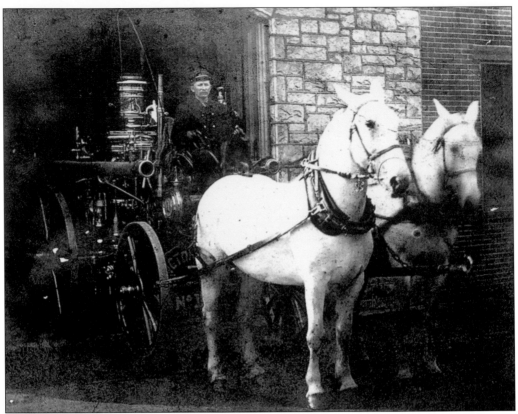

The citizens of Downingtown and their property have been protected from fire by the two borough fire companies for more than a century. During the early days, equipment was drawn by horses. The postcard above was used as a birthday greeting in 1908 and shows two of the horses standing ready to pull a piece of equipment to the fire. In the photograph below, firemen have a little fun while practicing their firefighting techniques.

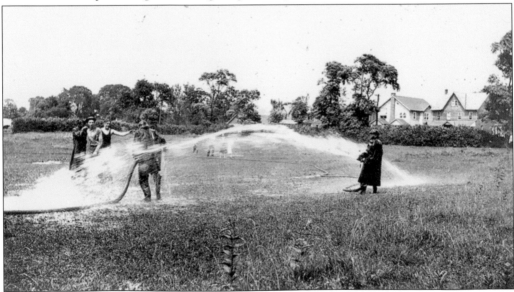